inspired boldring

TATTOOS

COLORING TO RELAX AND FREE YOUR MIND

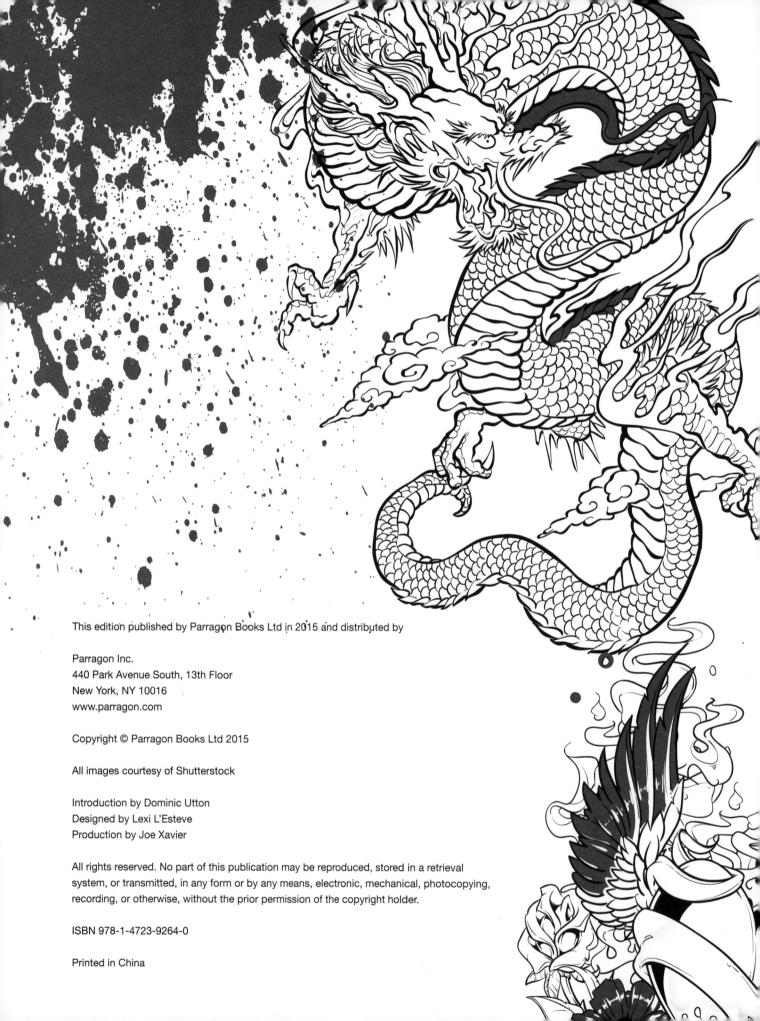

TATTOOS

COLORING TO RELAX AND FREE YOUR MIND

Bath • New York • Cologne • Melbourne • Delhi

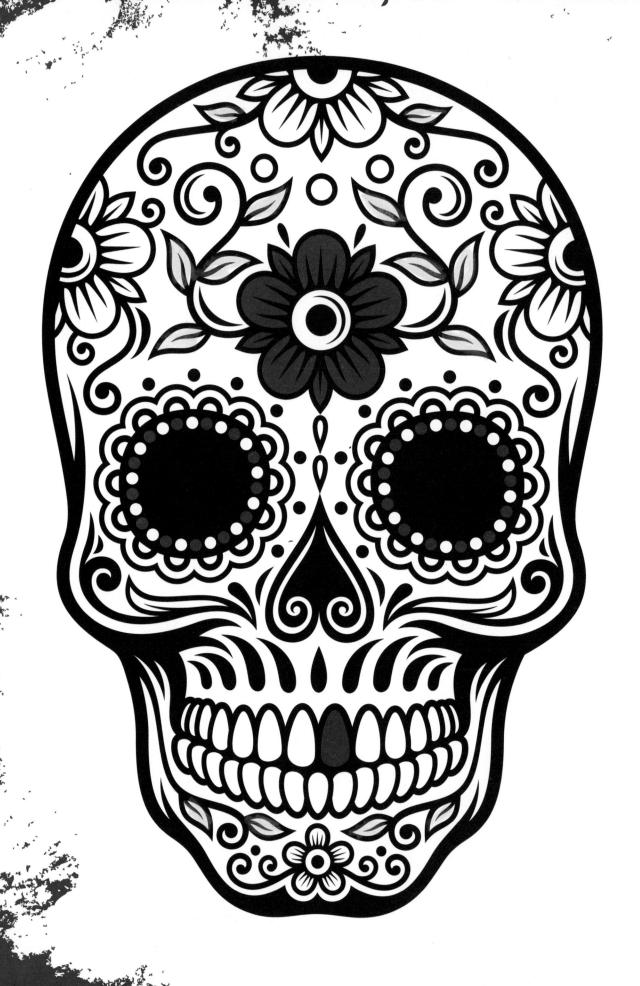

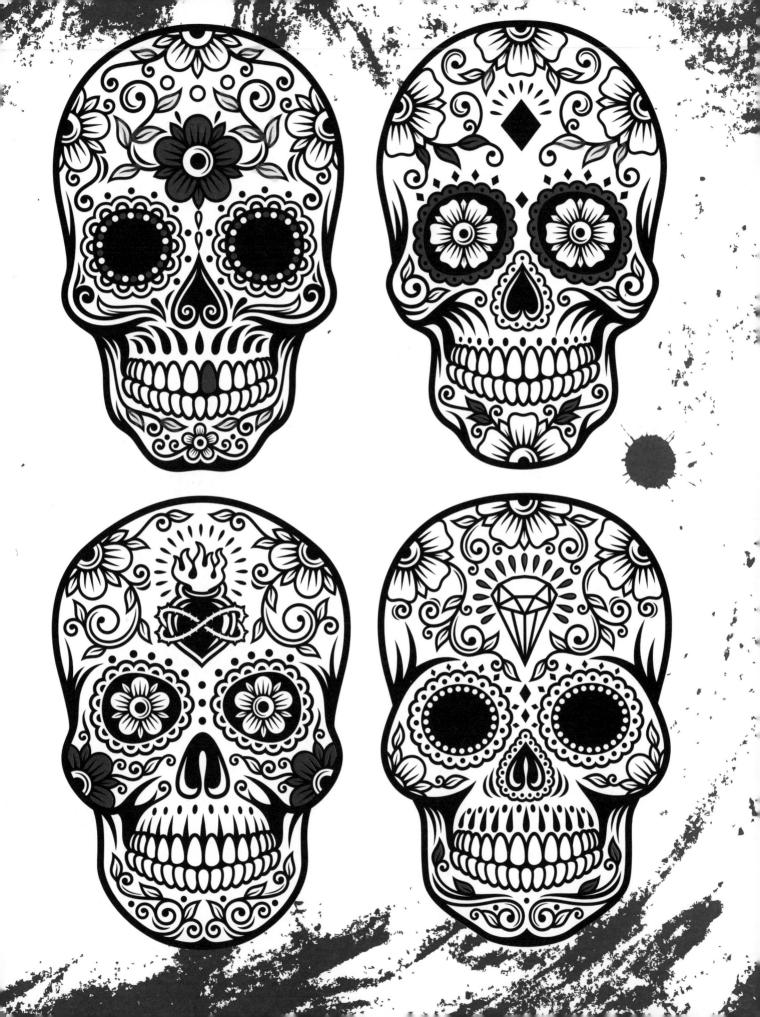

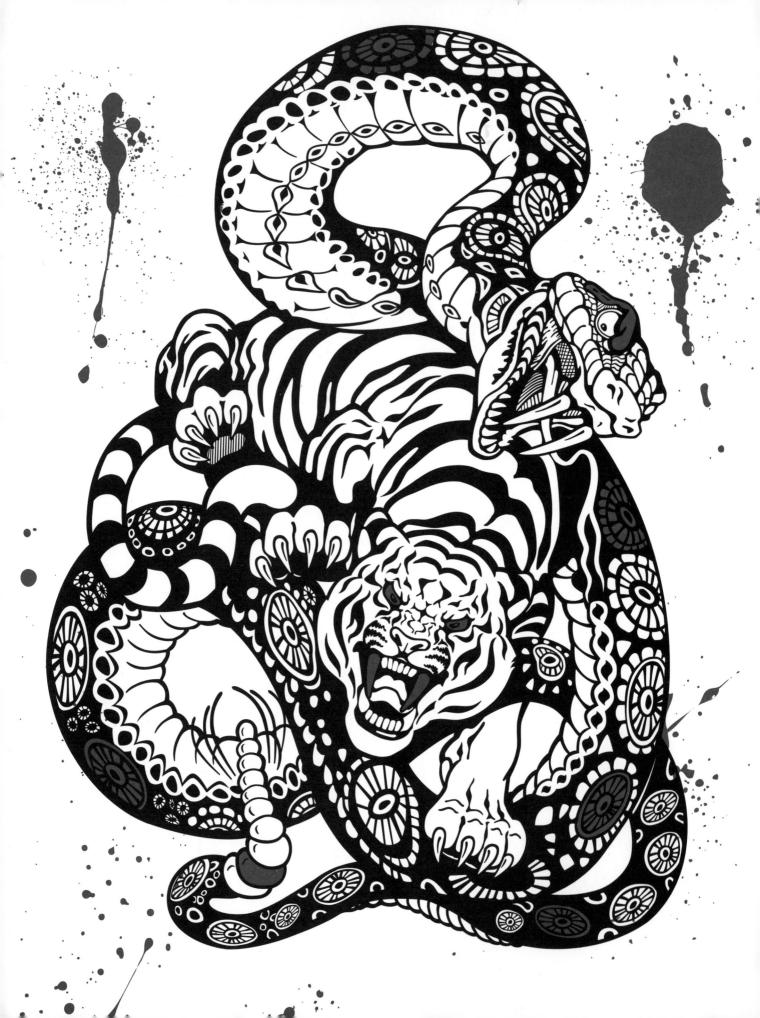

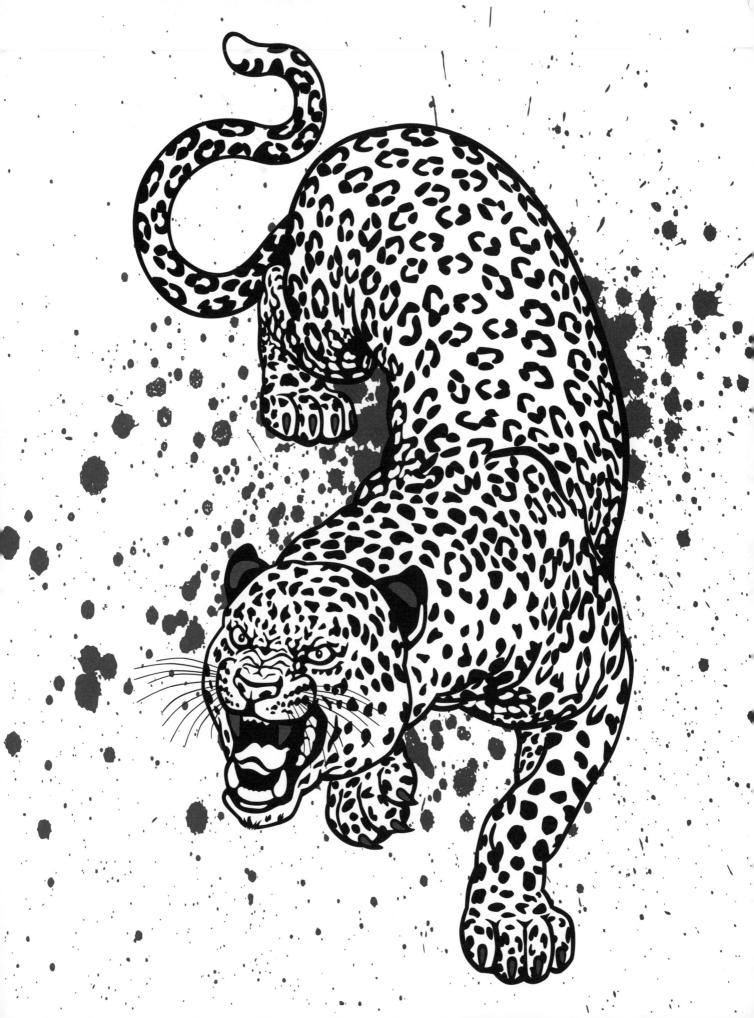

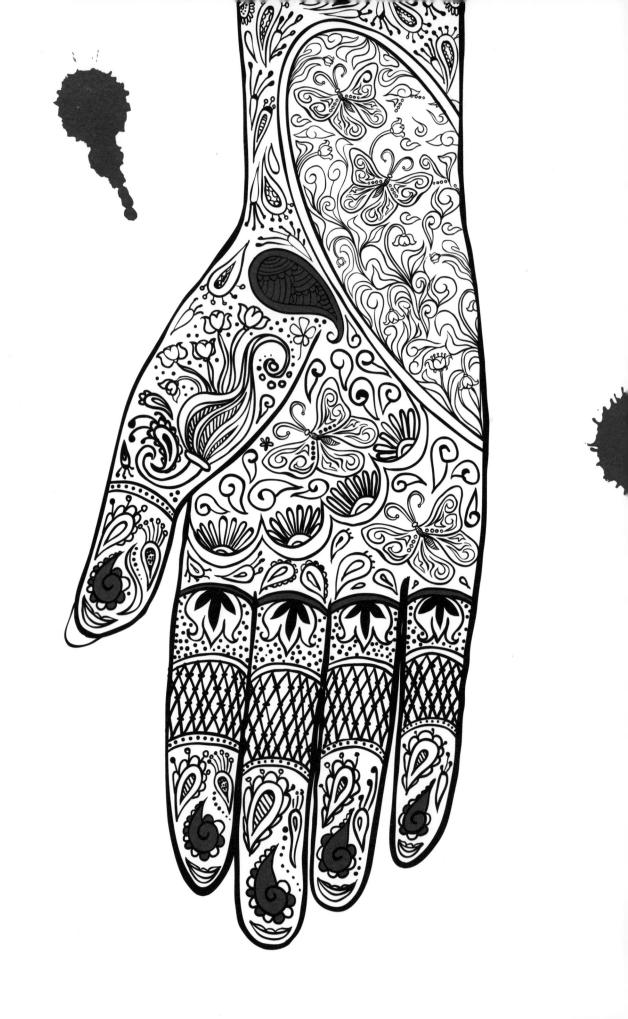

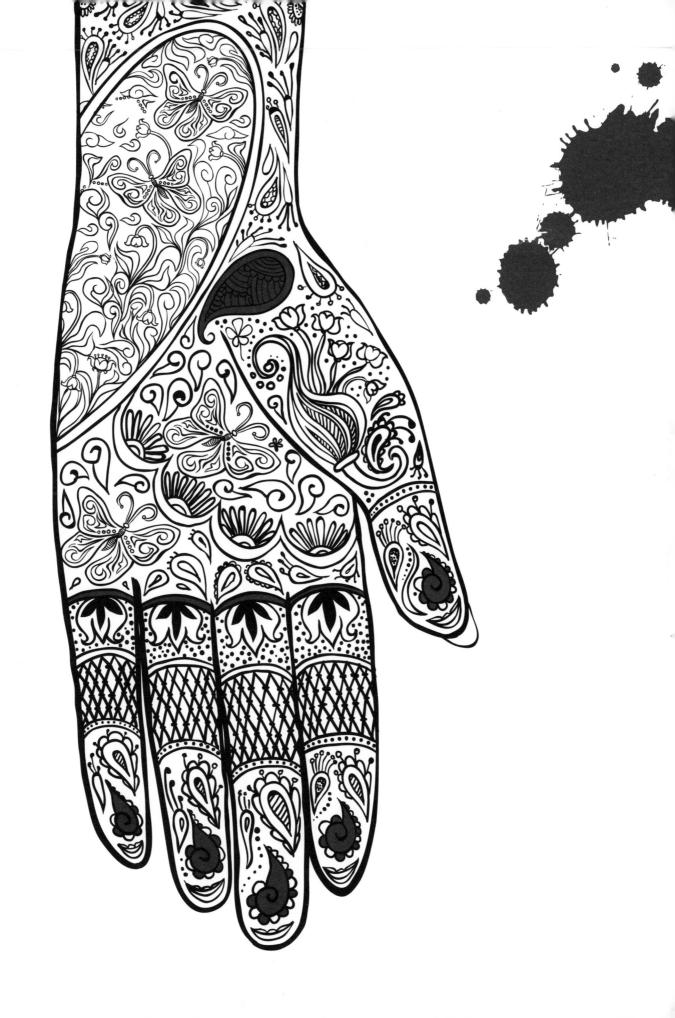

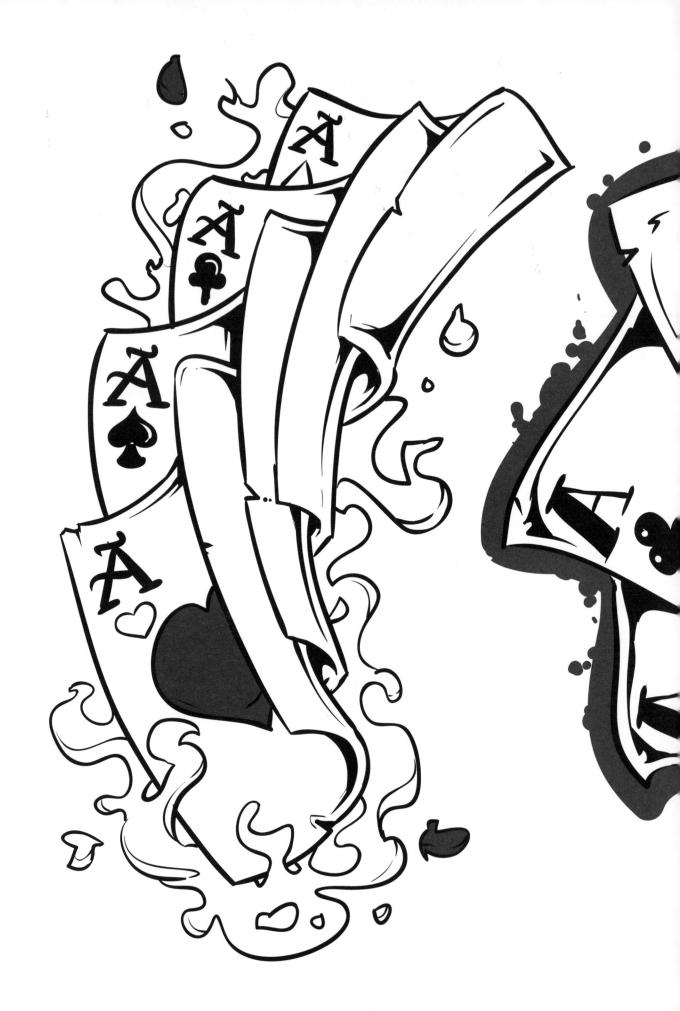

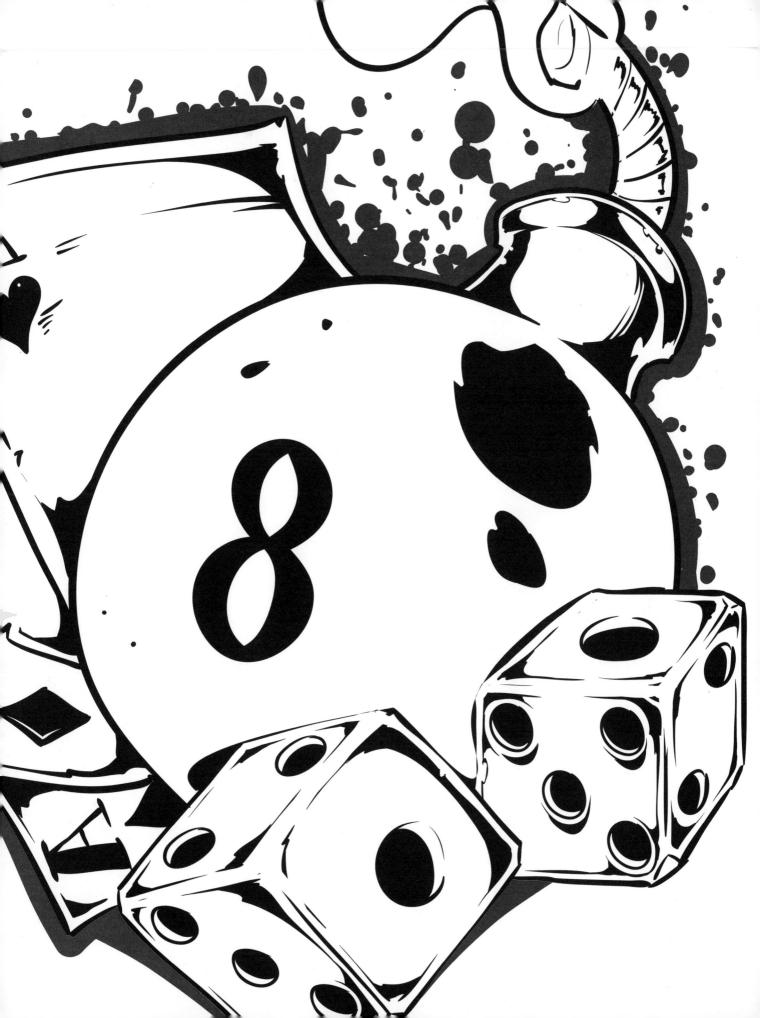

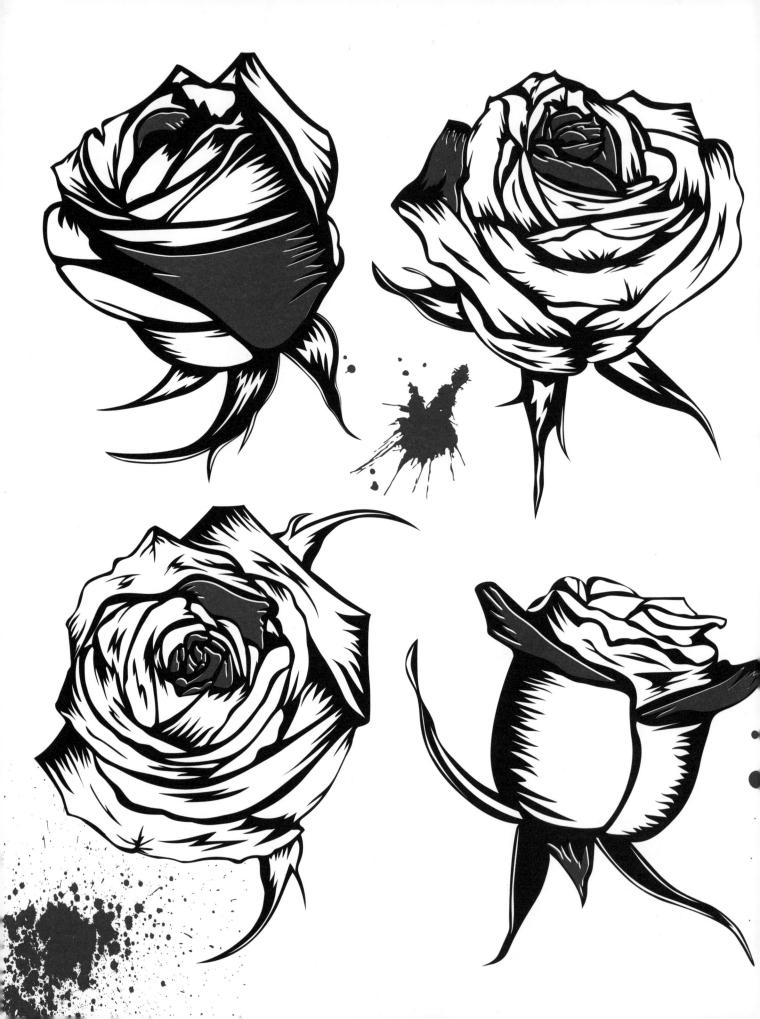

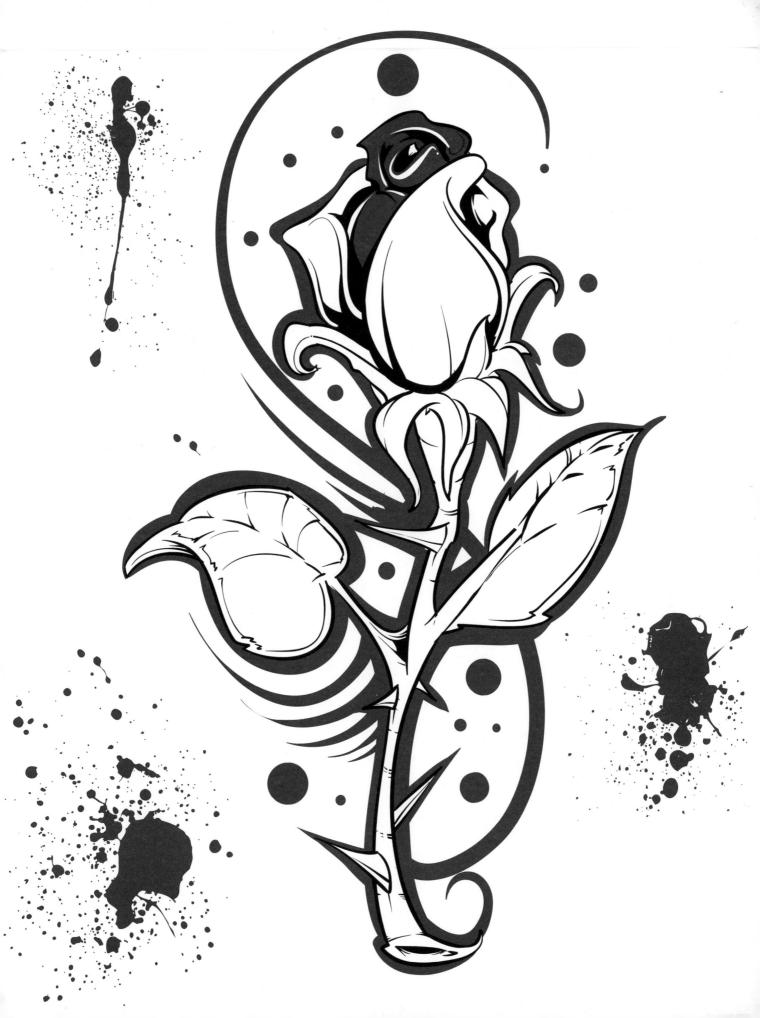

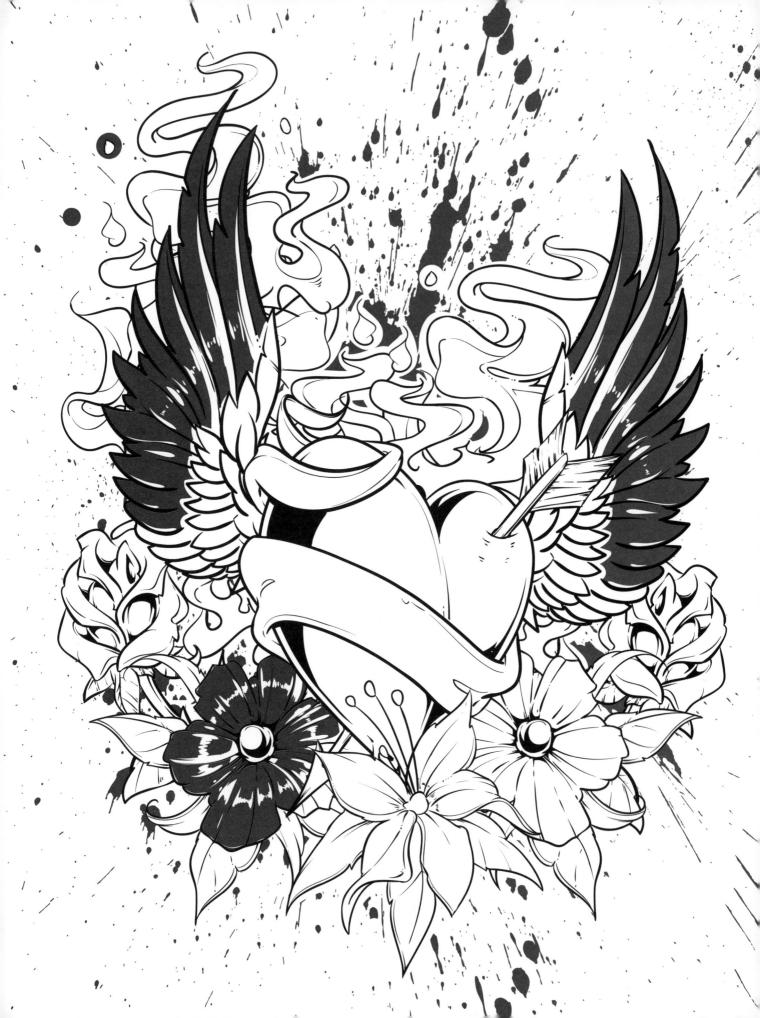

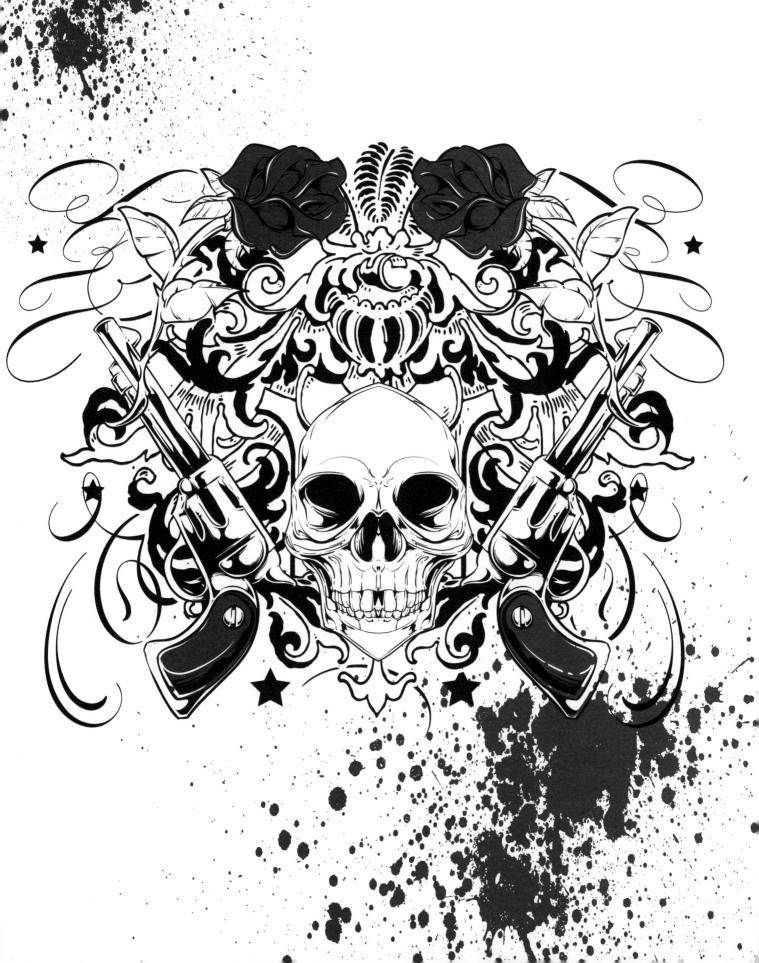

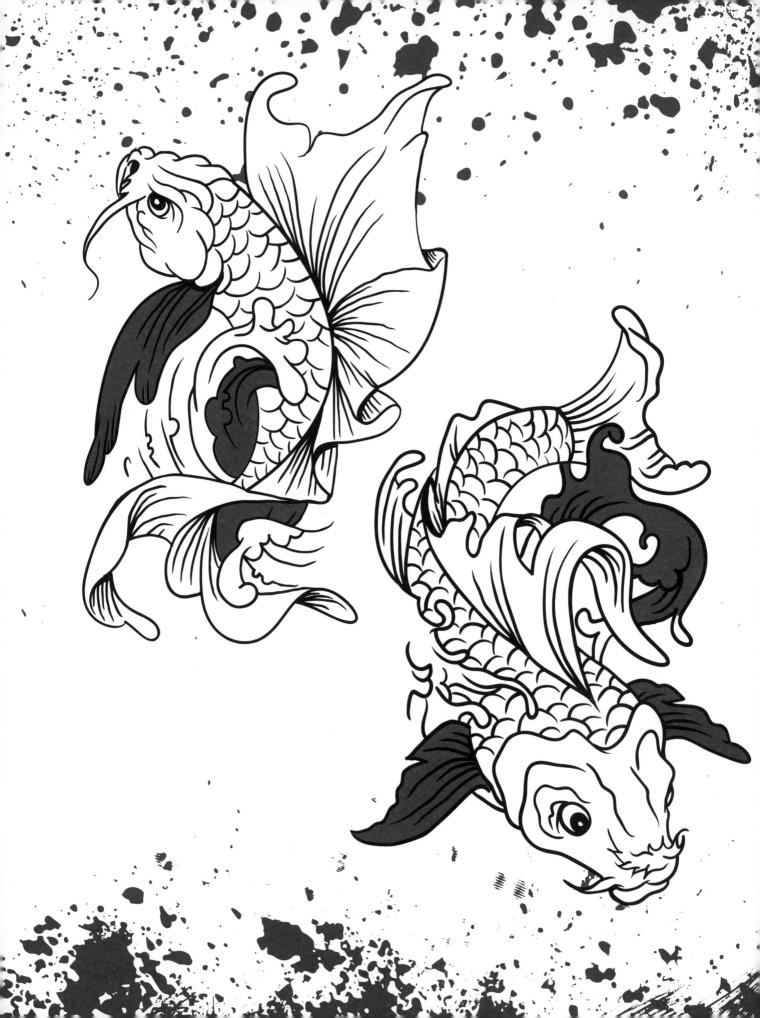

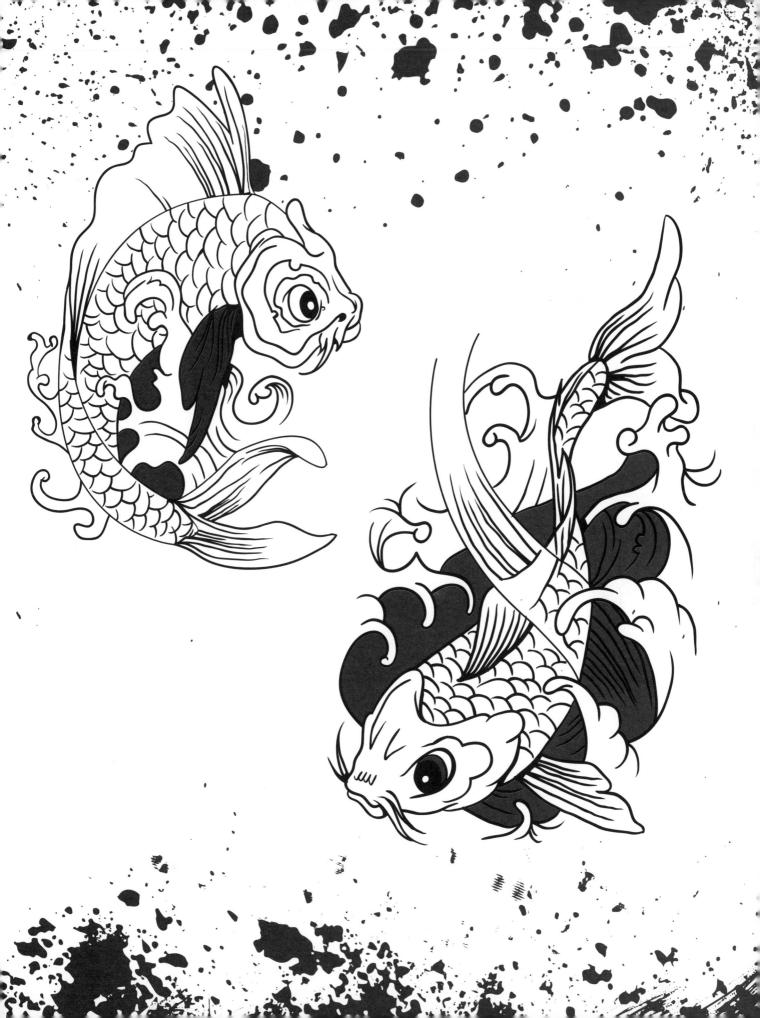

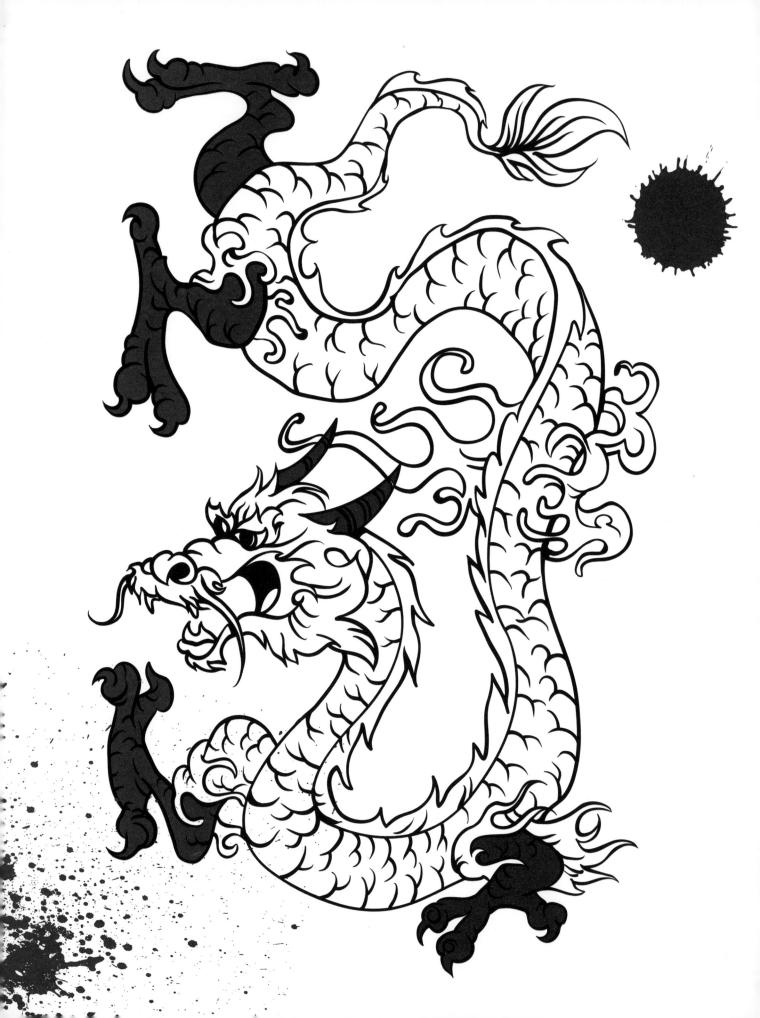

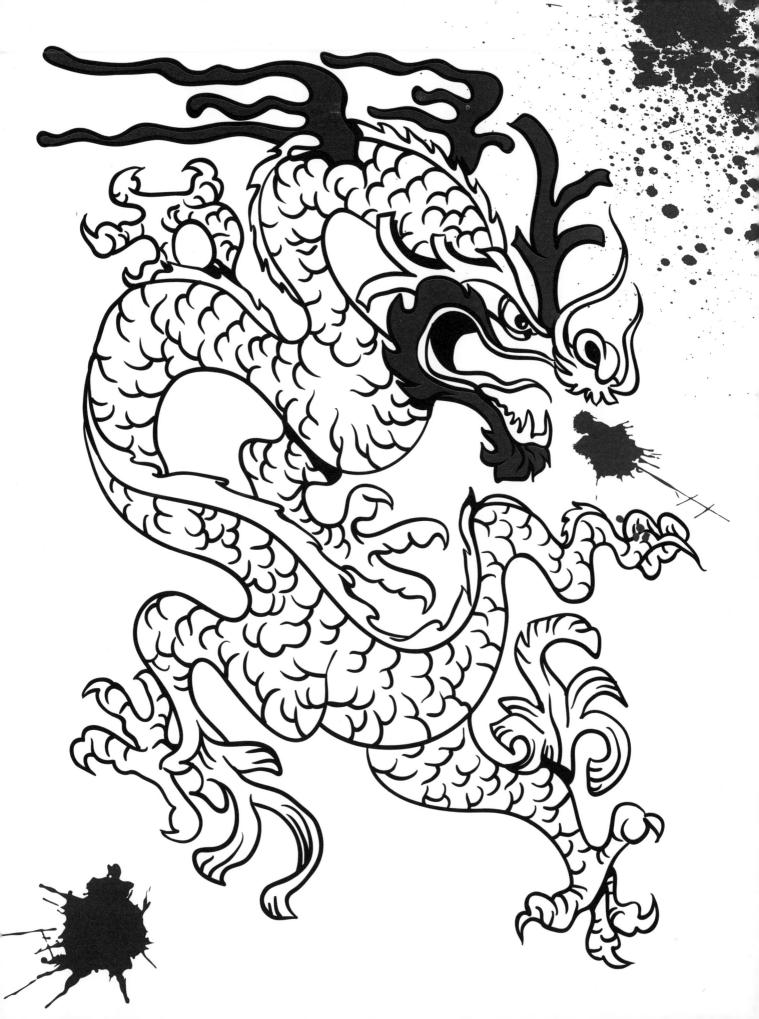

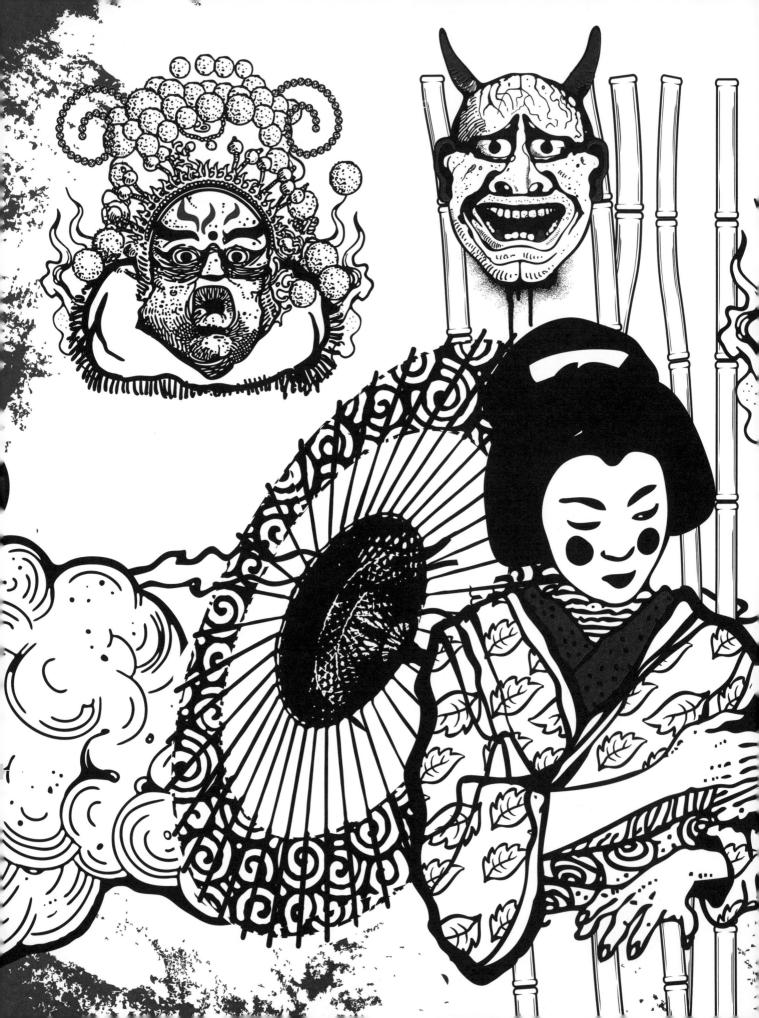

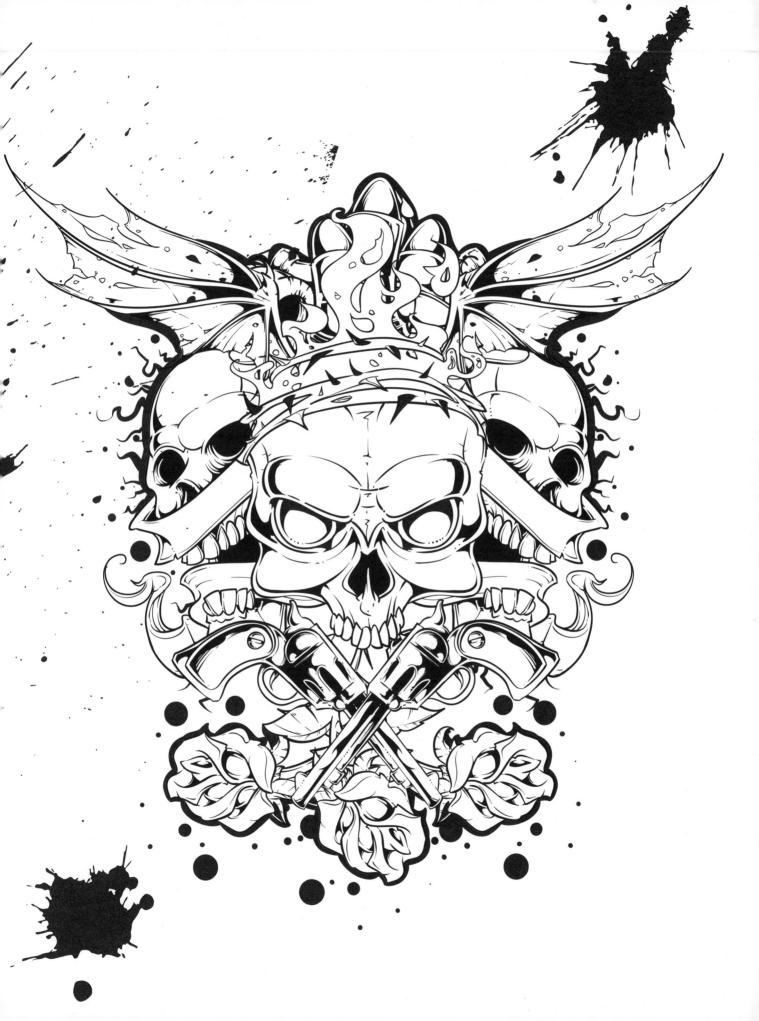

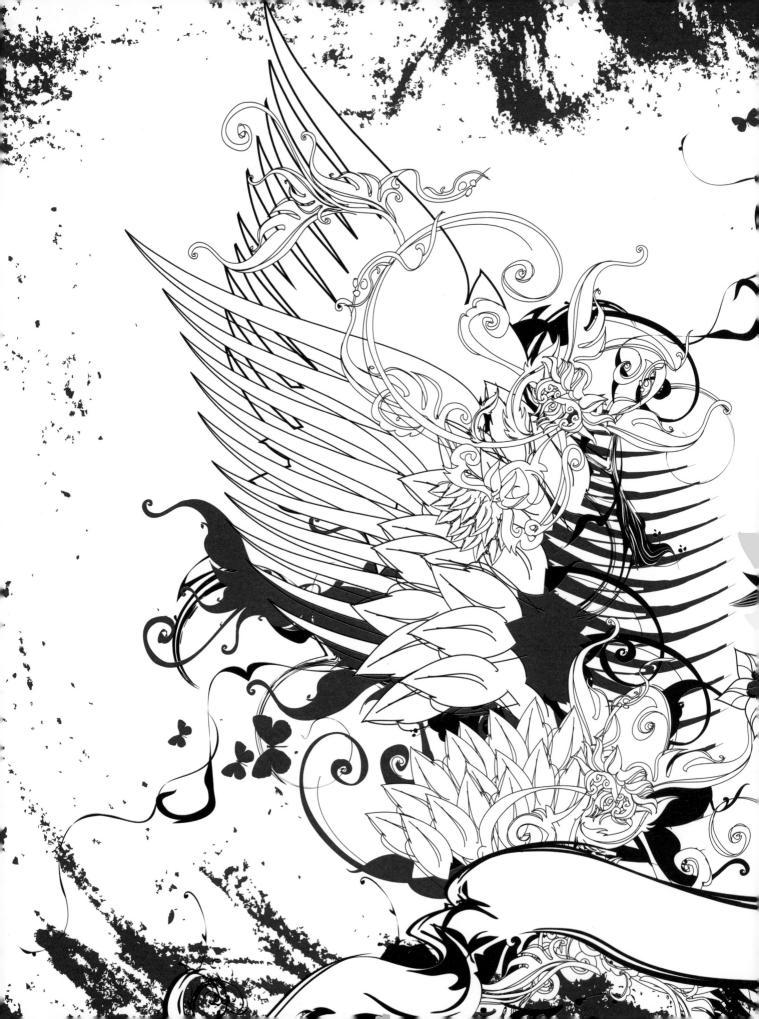

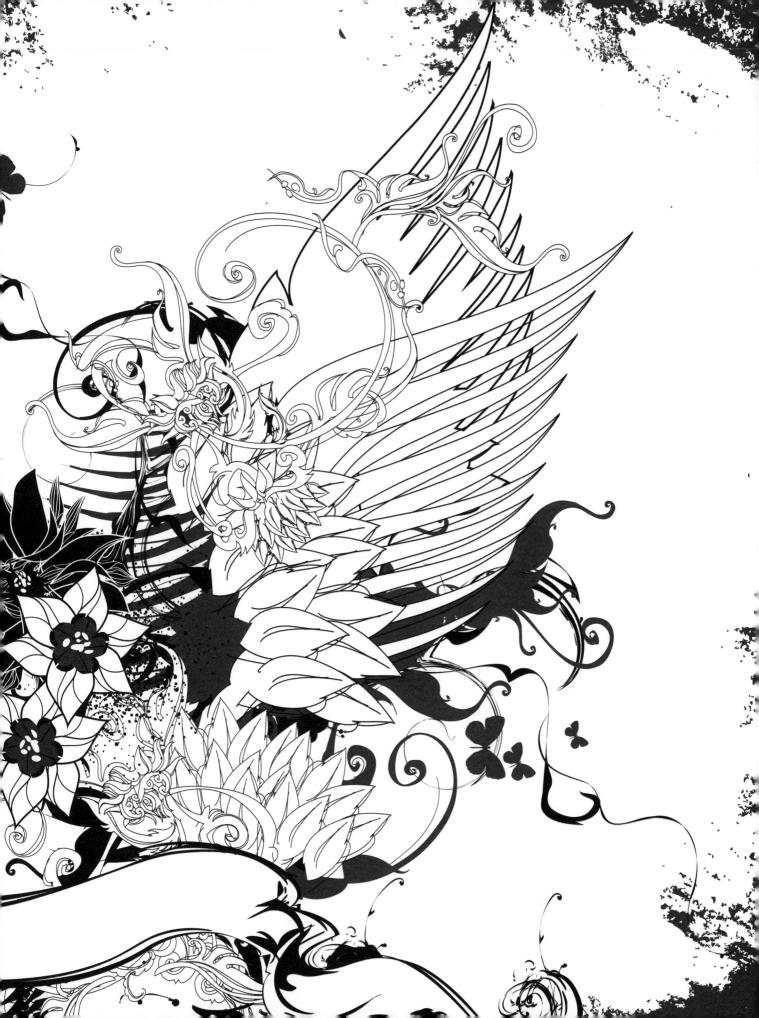

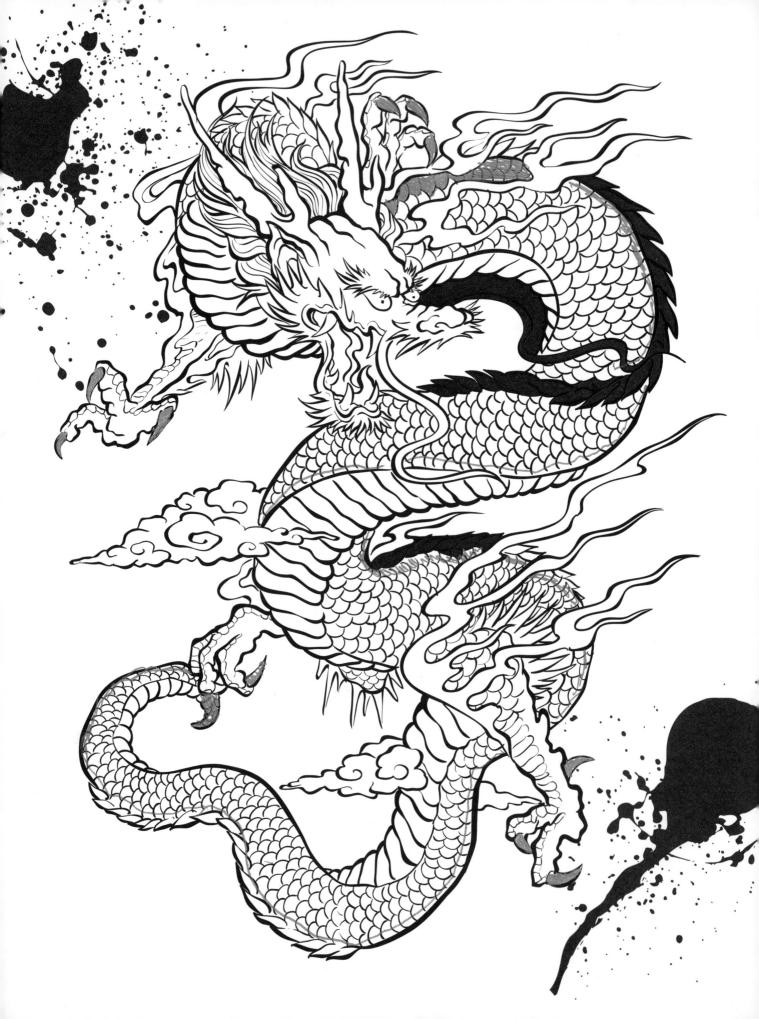

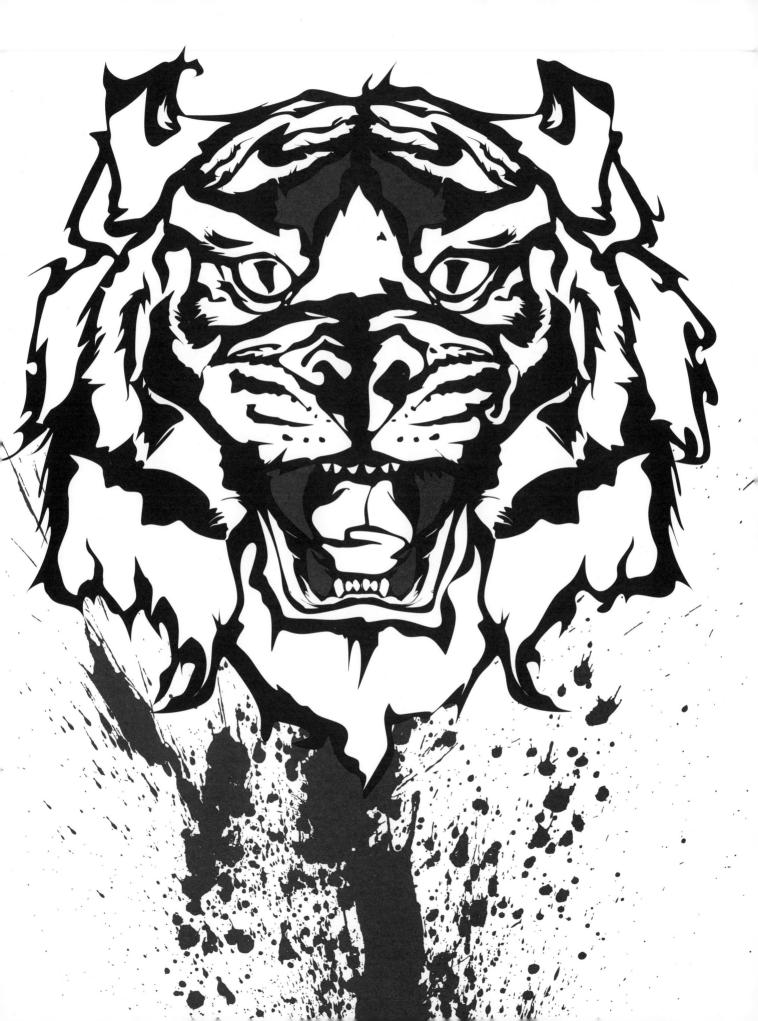

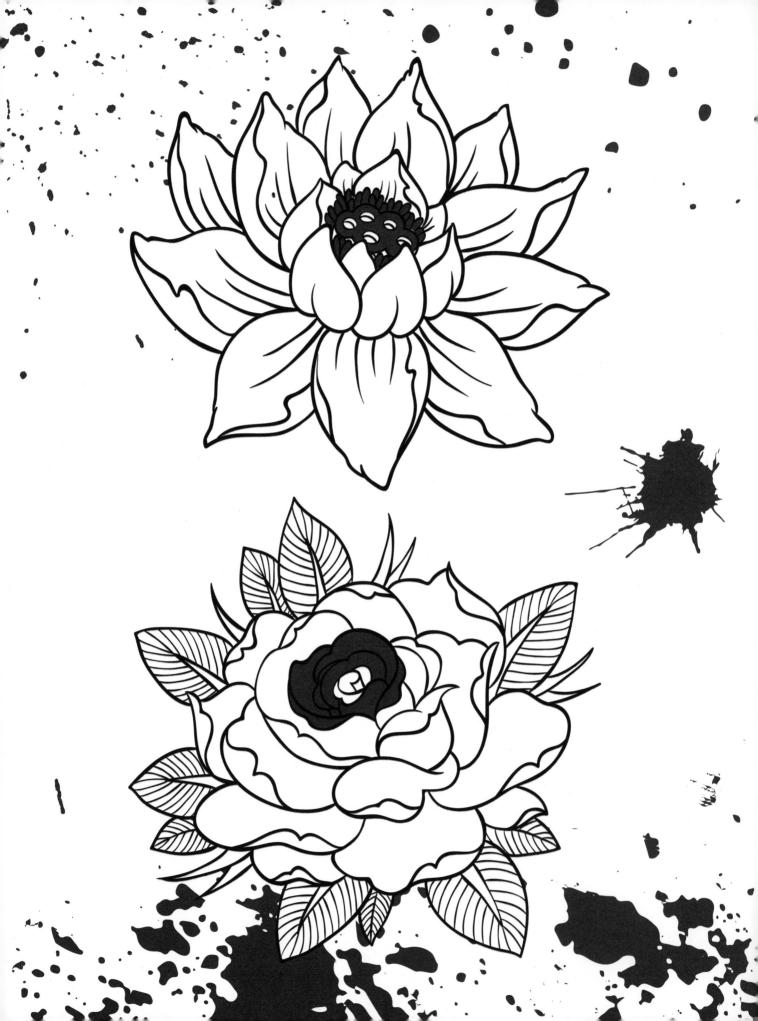

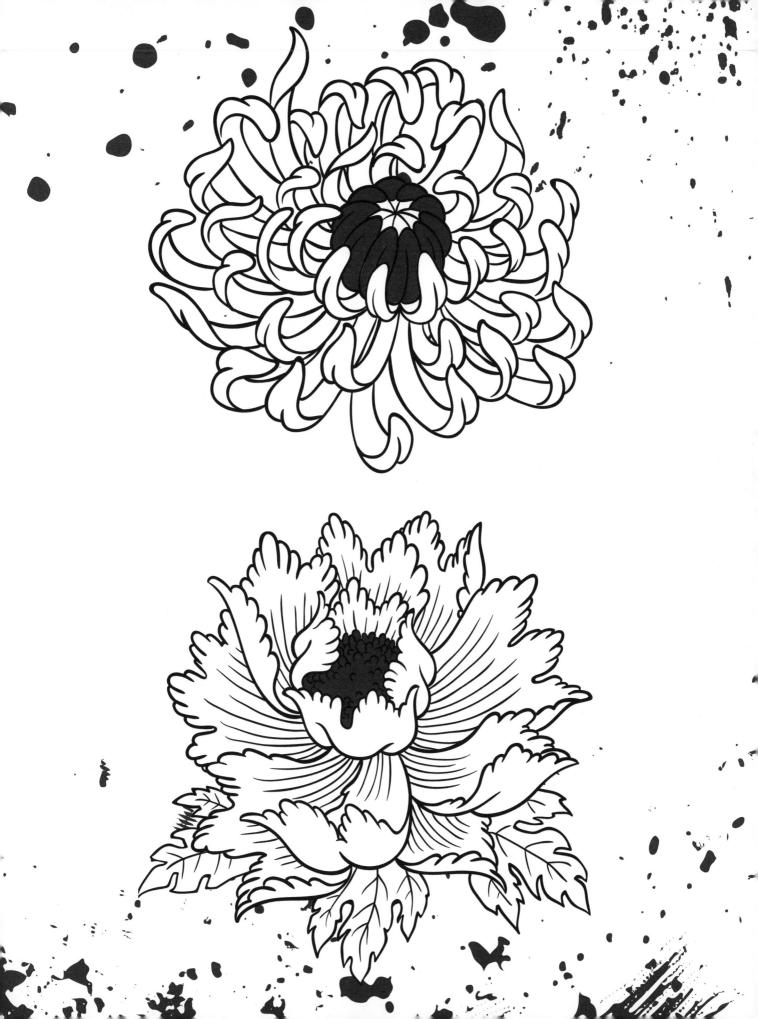

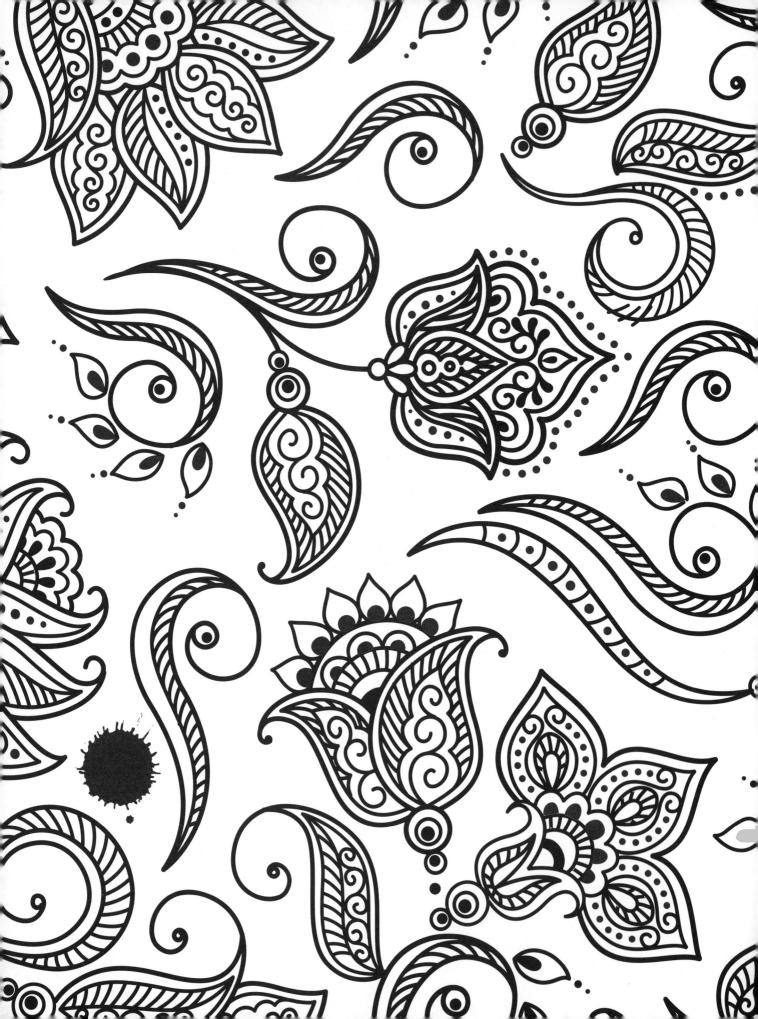

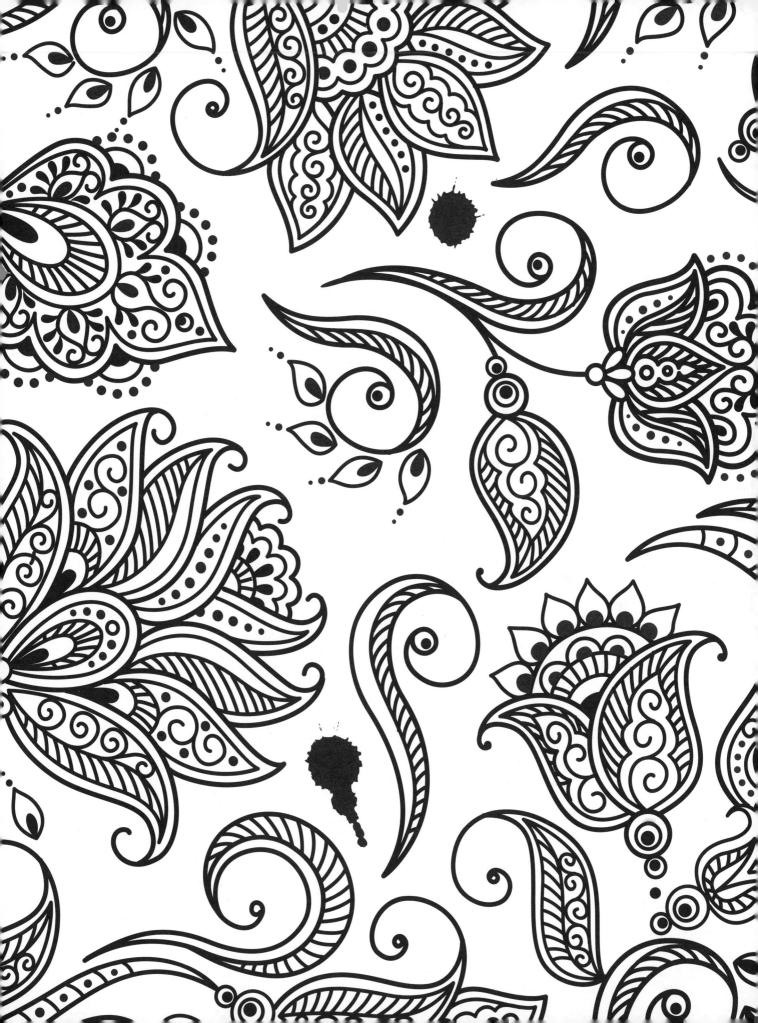

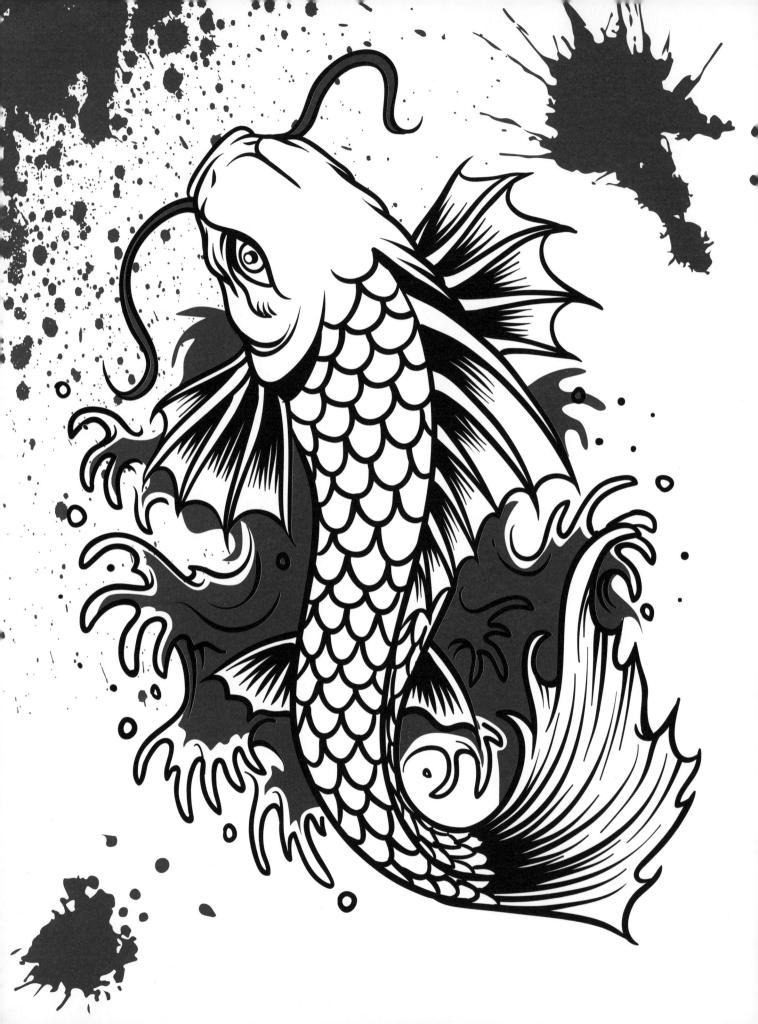

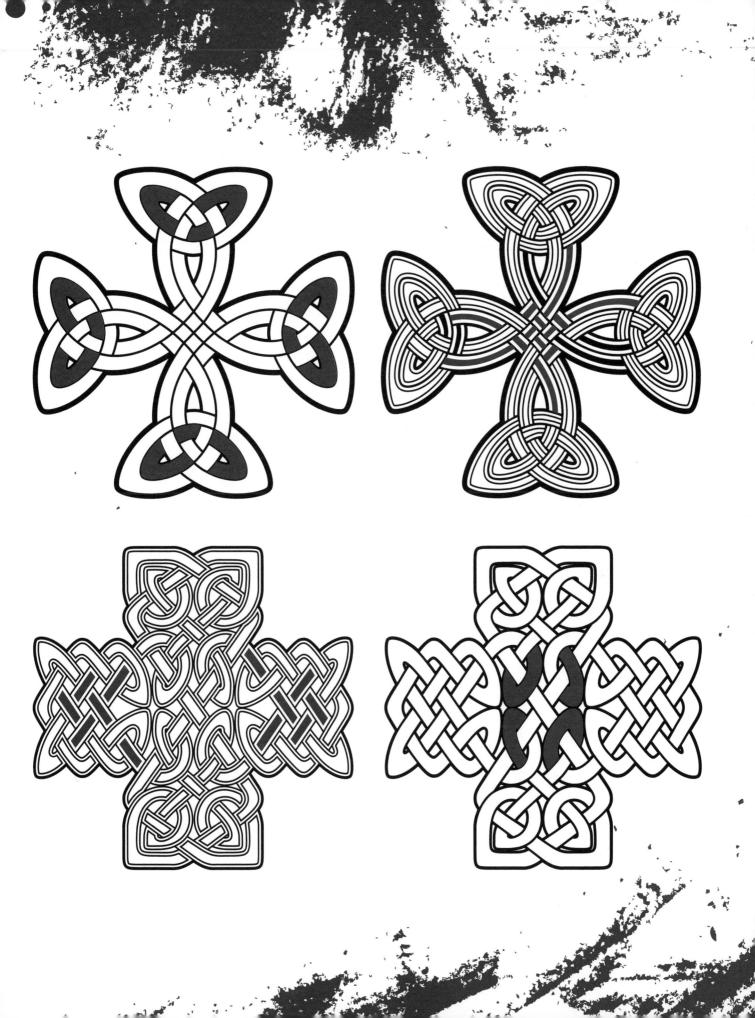

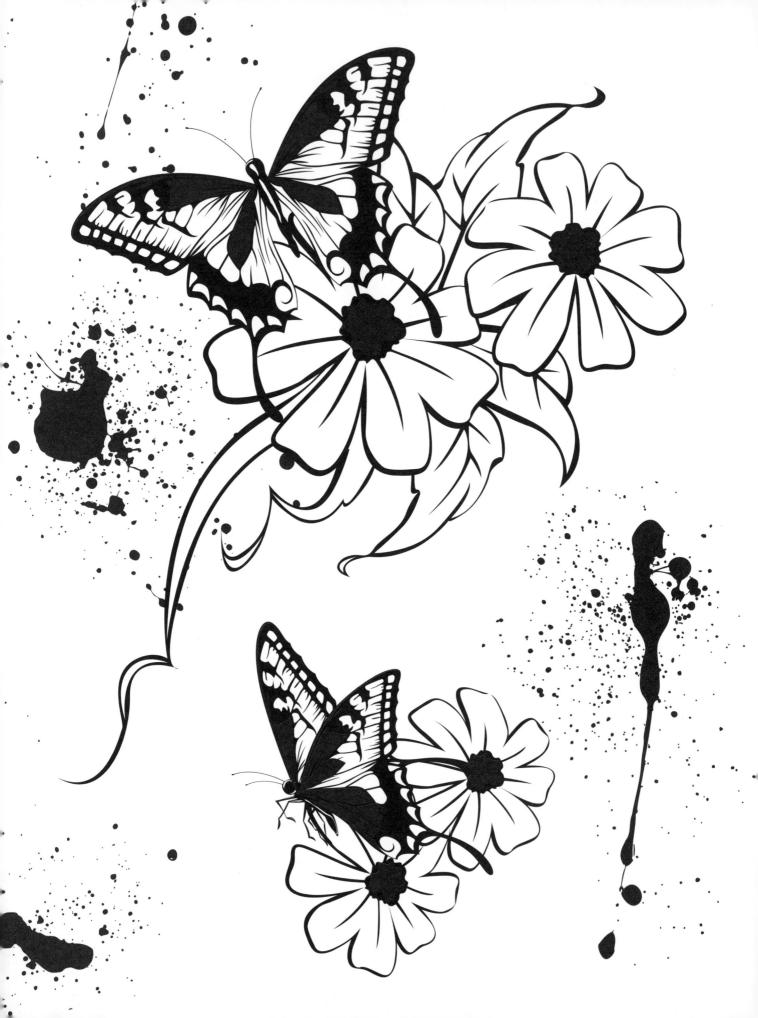

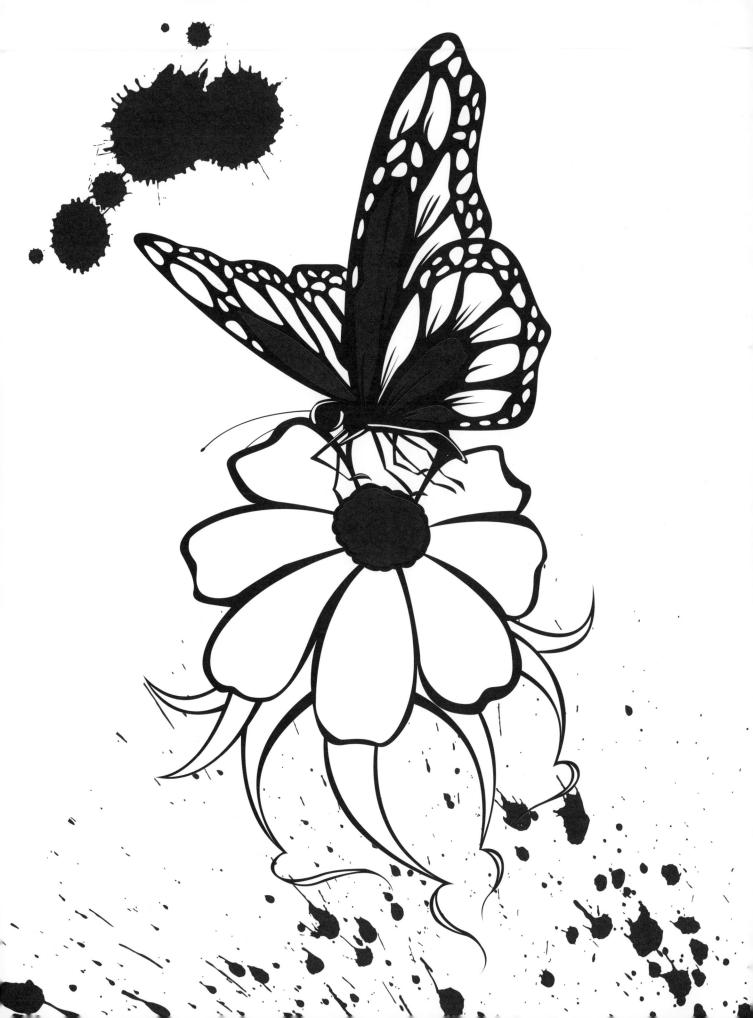

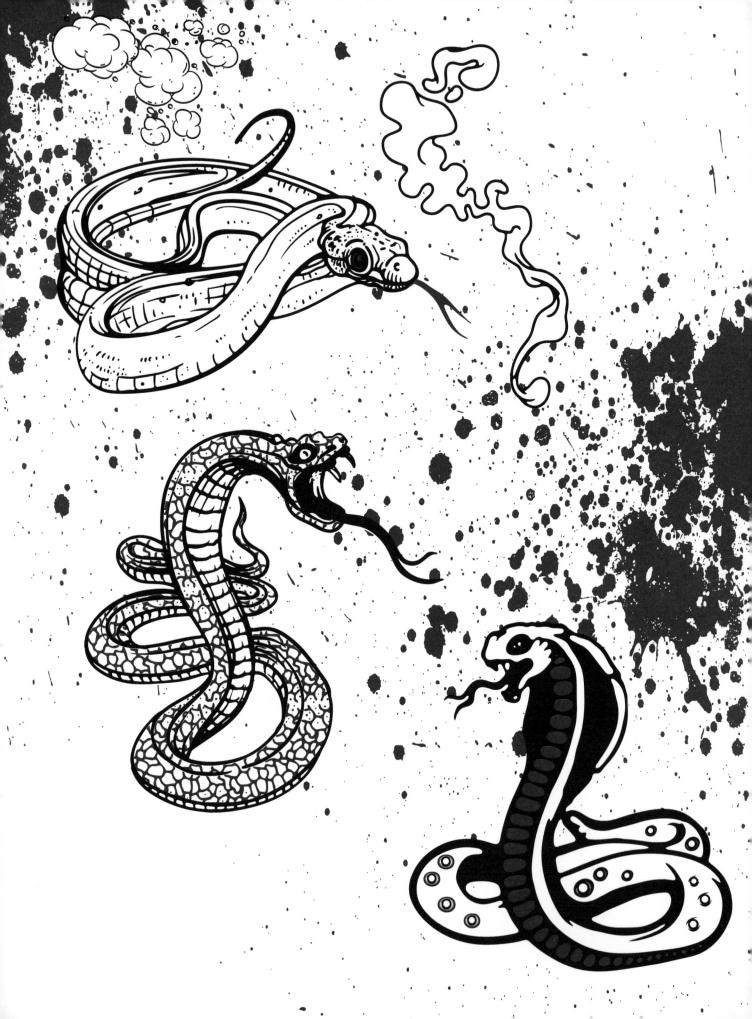

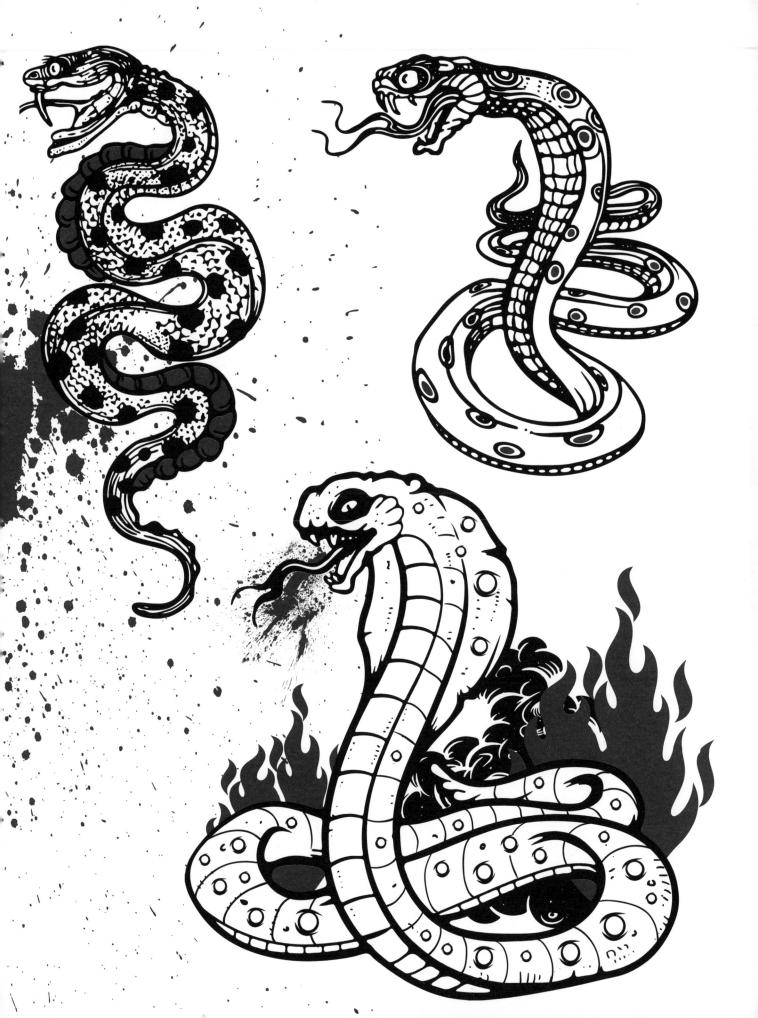

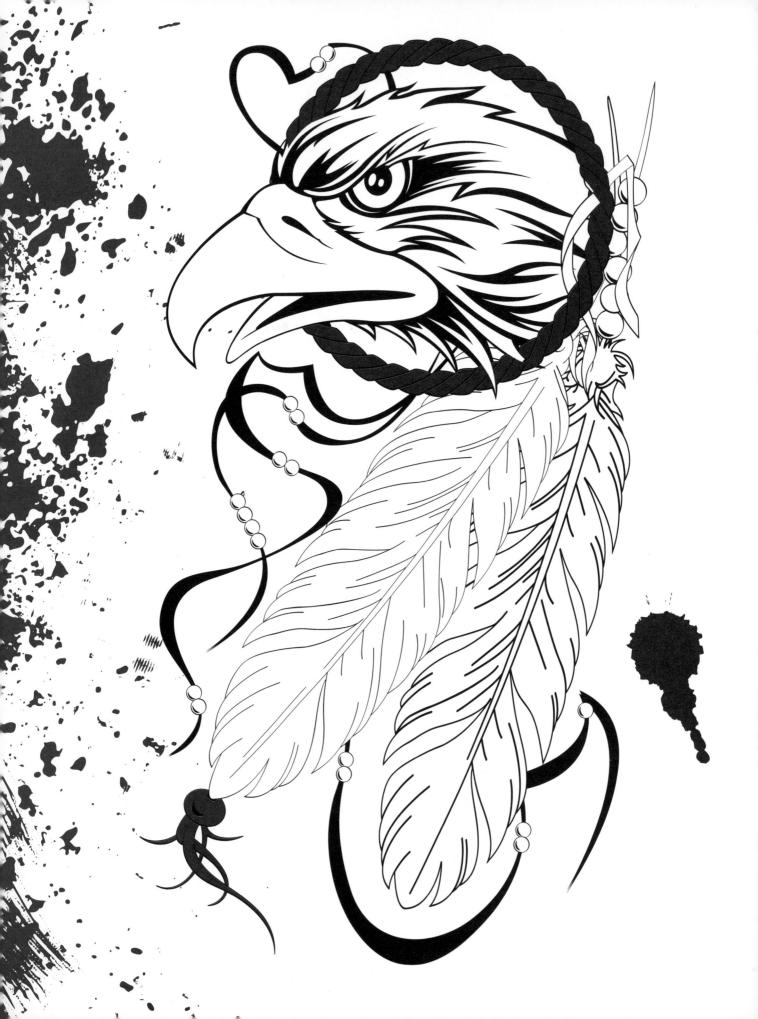

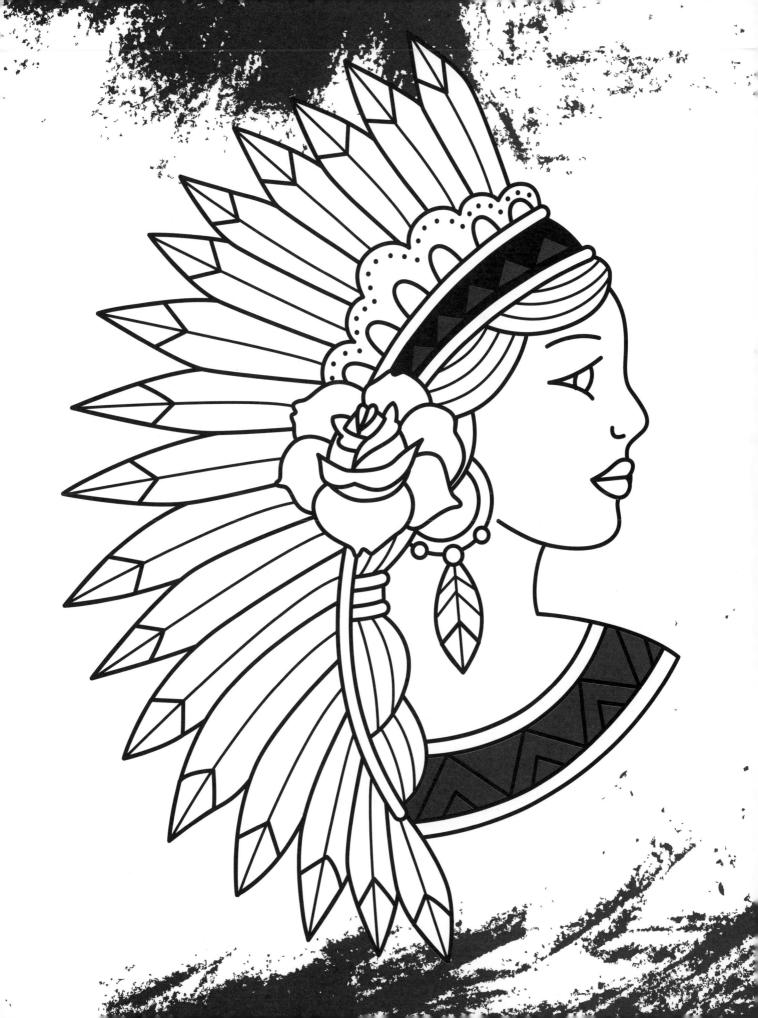

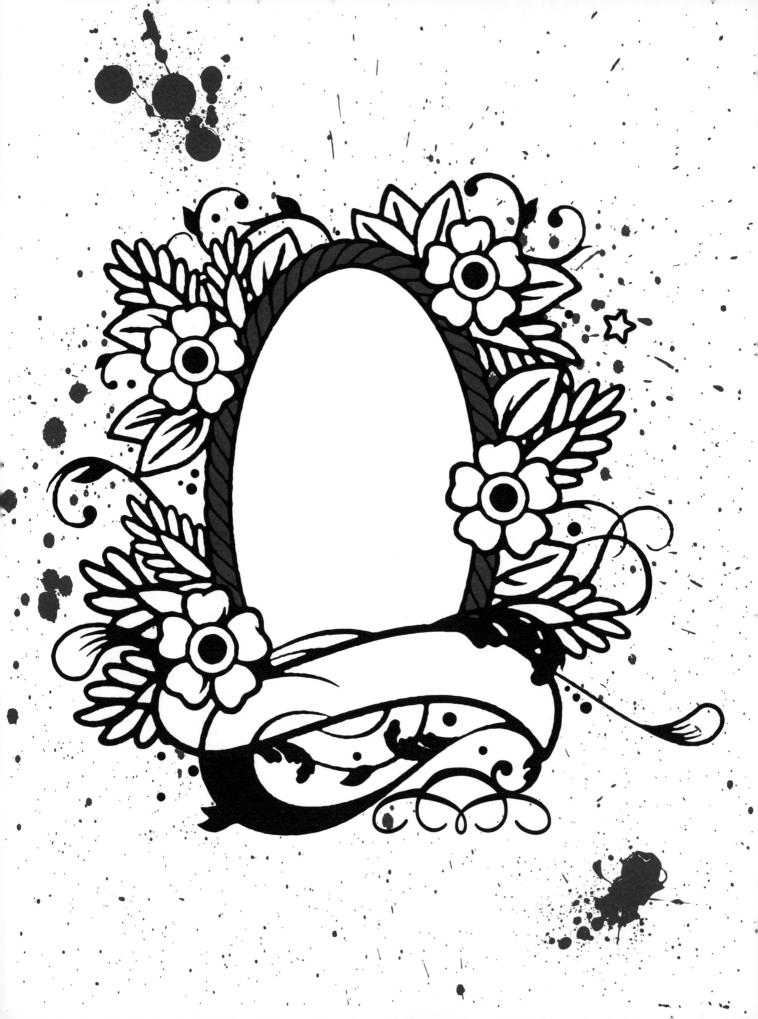

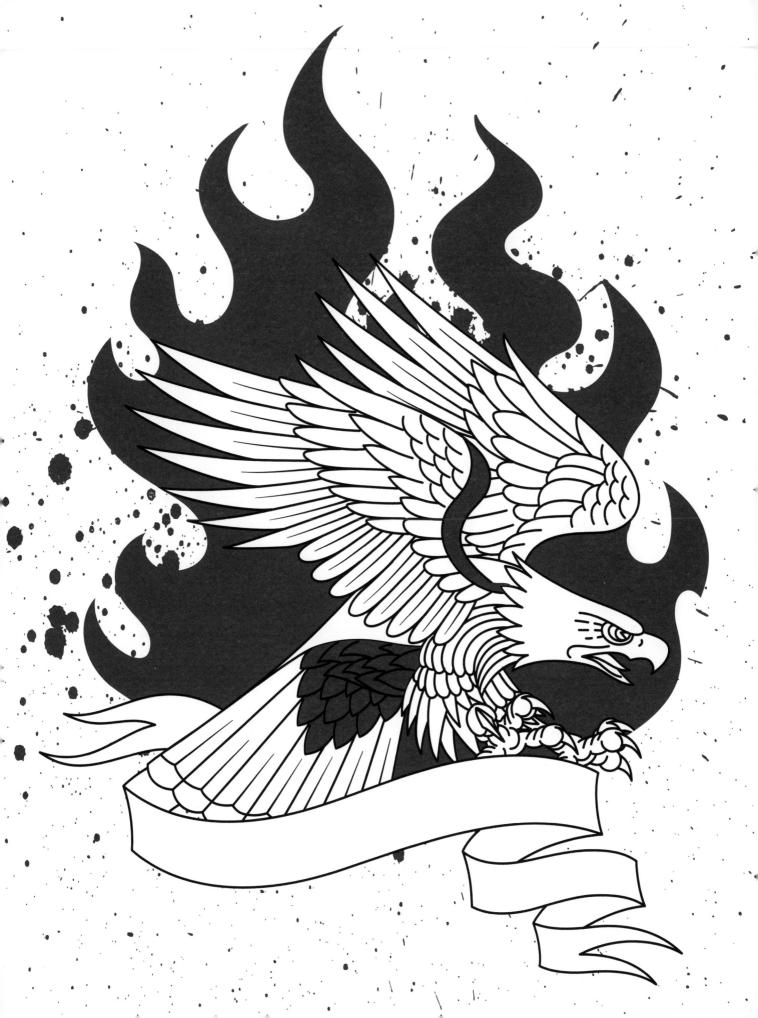

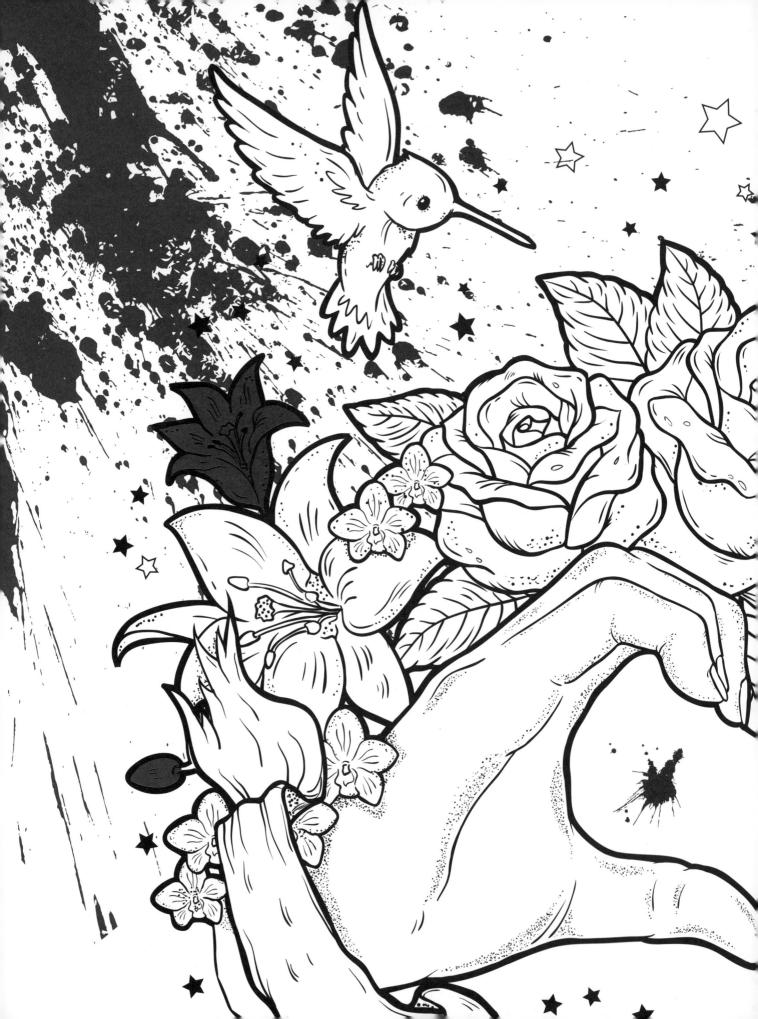

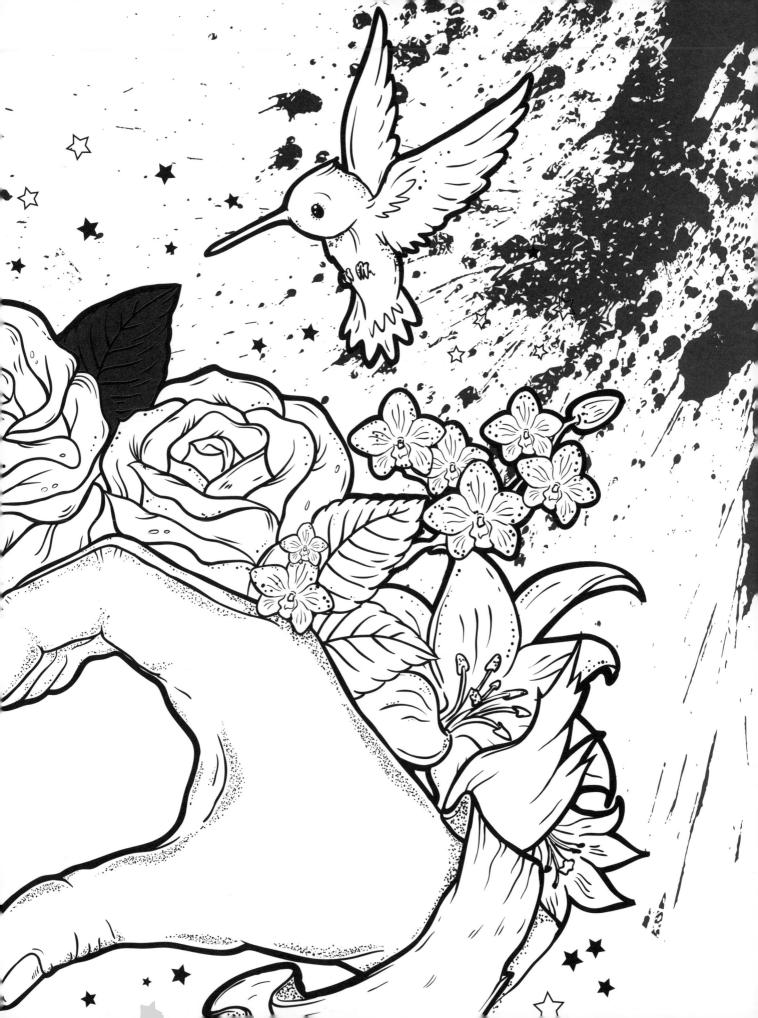

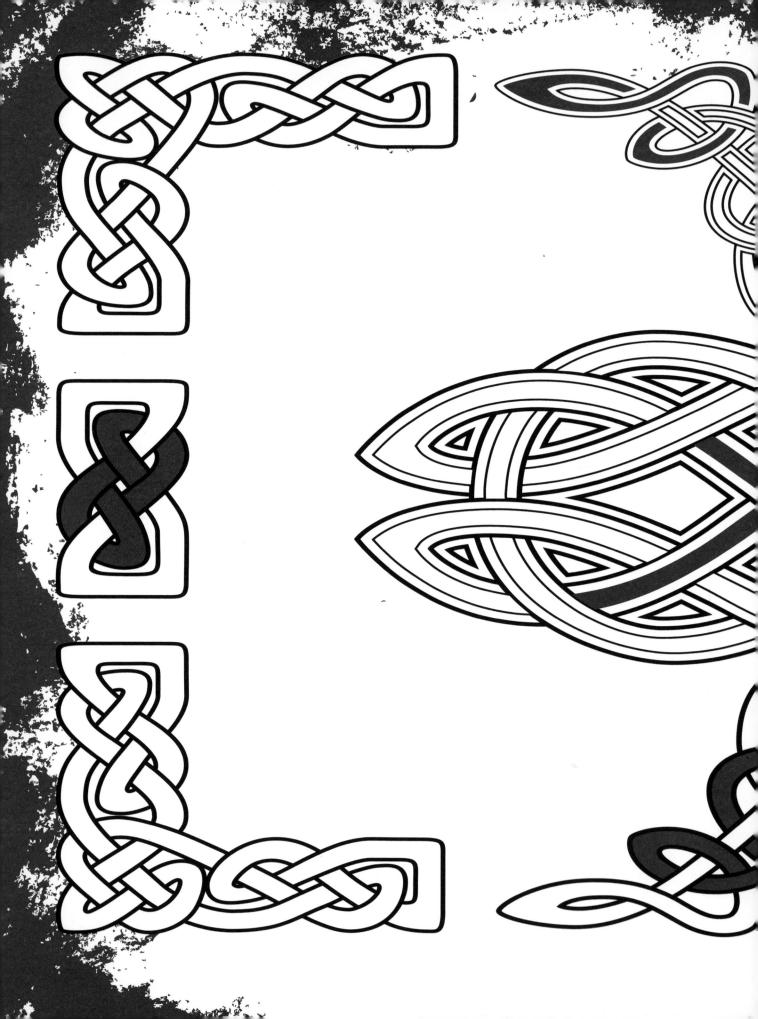

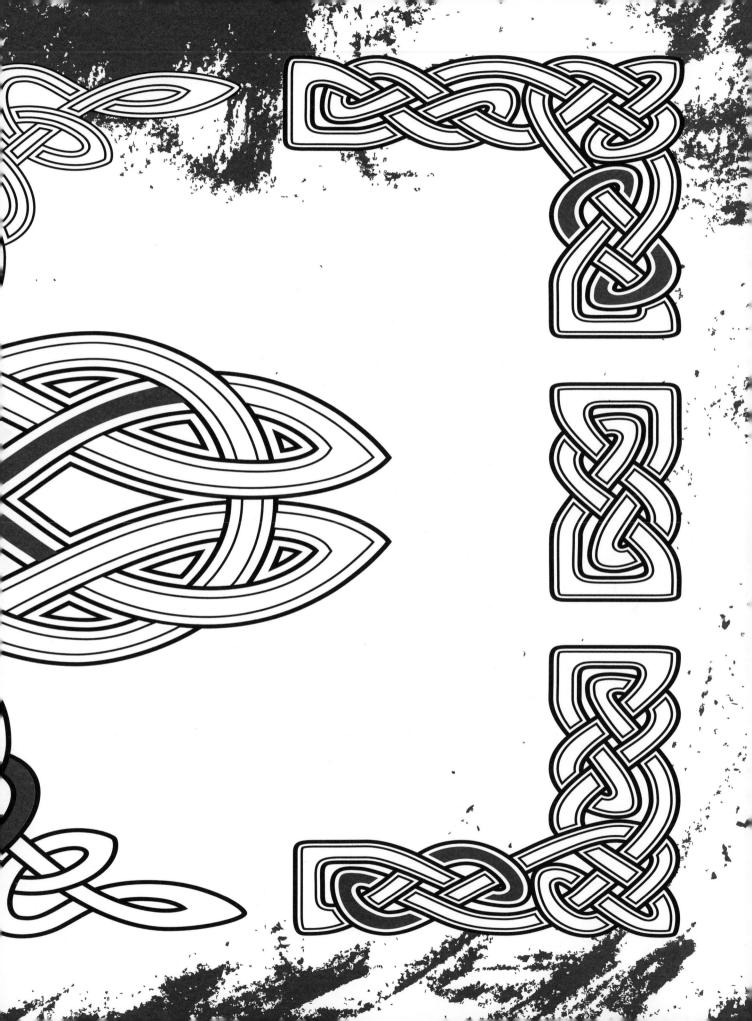

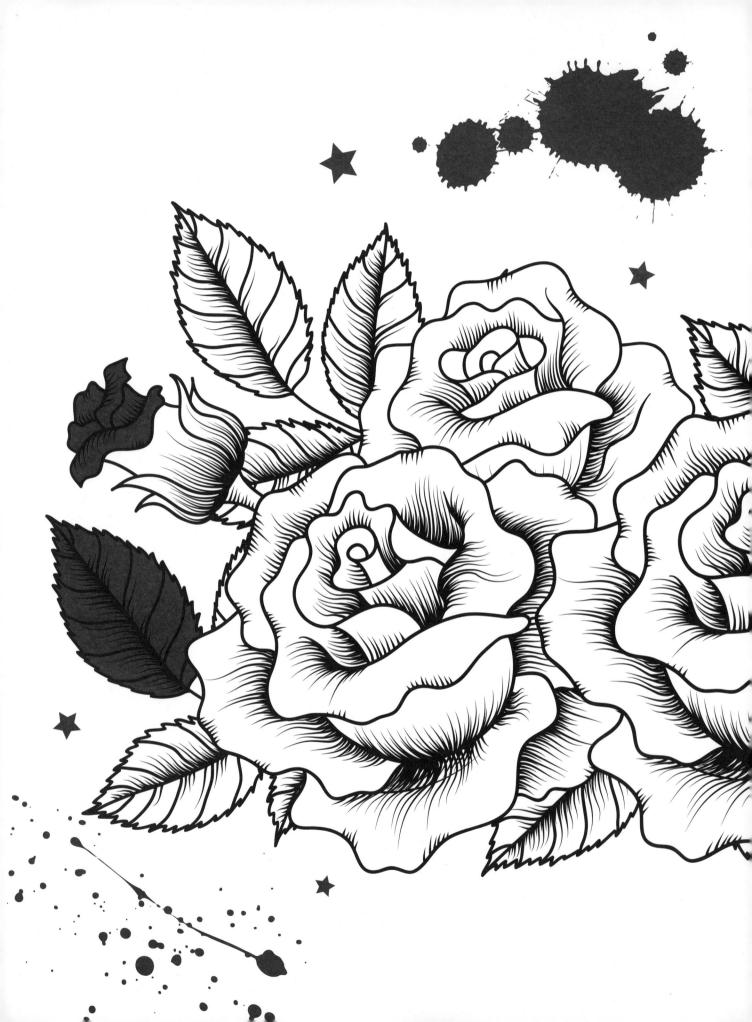

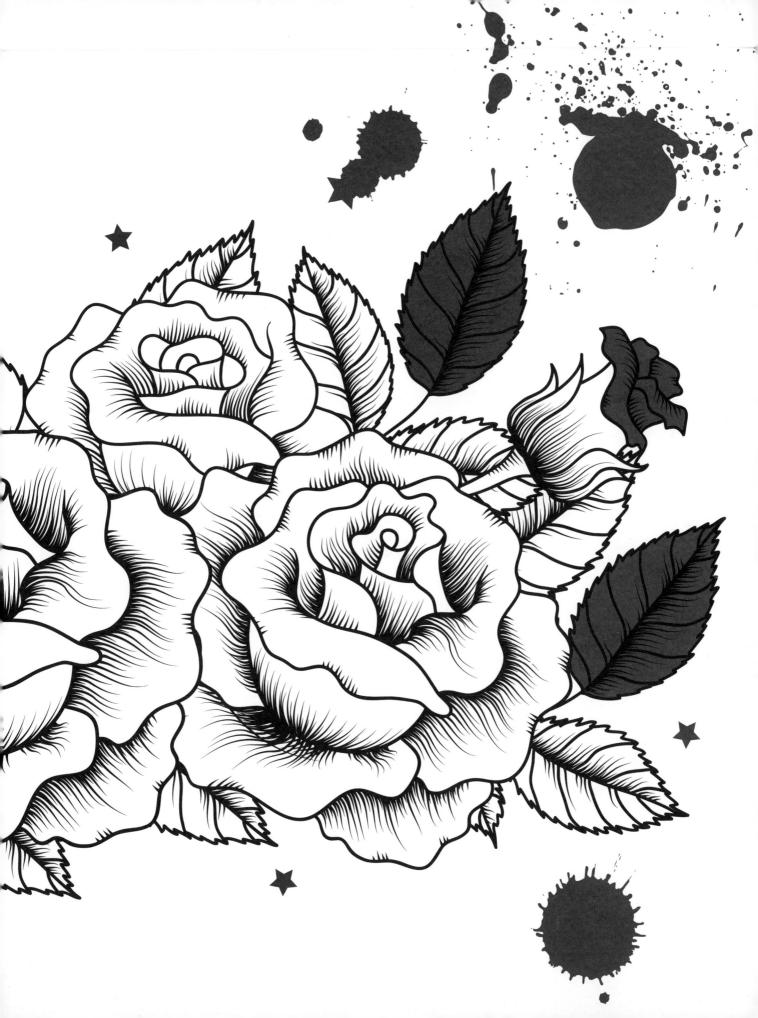

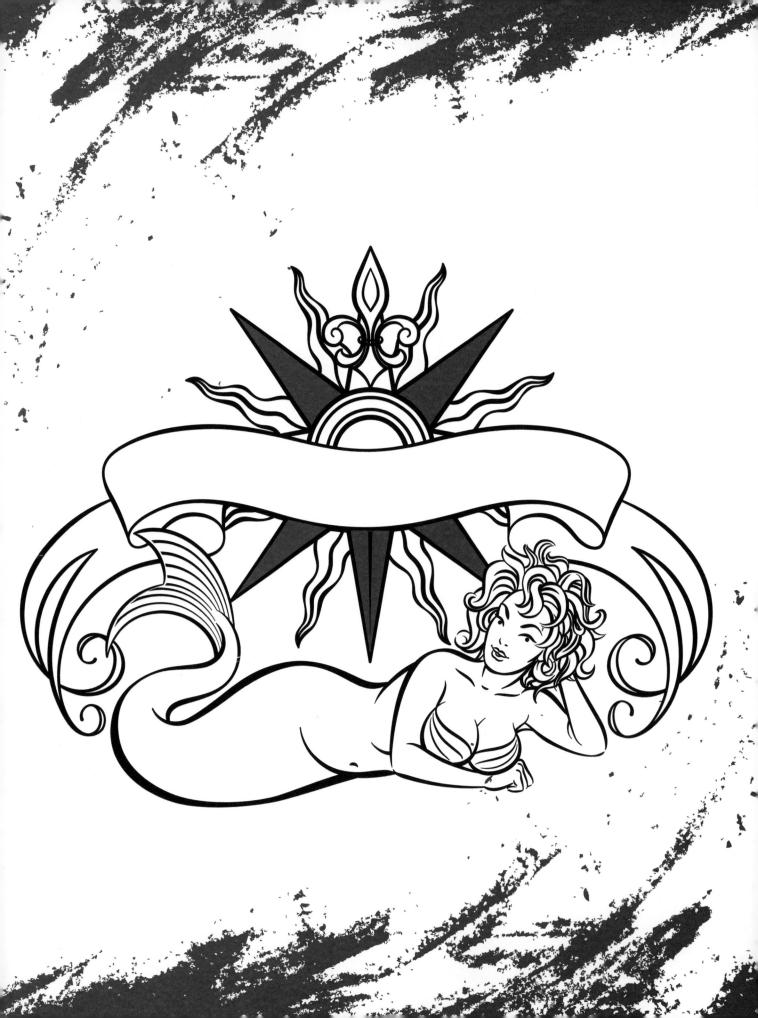

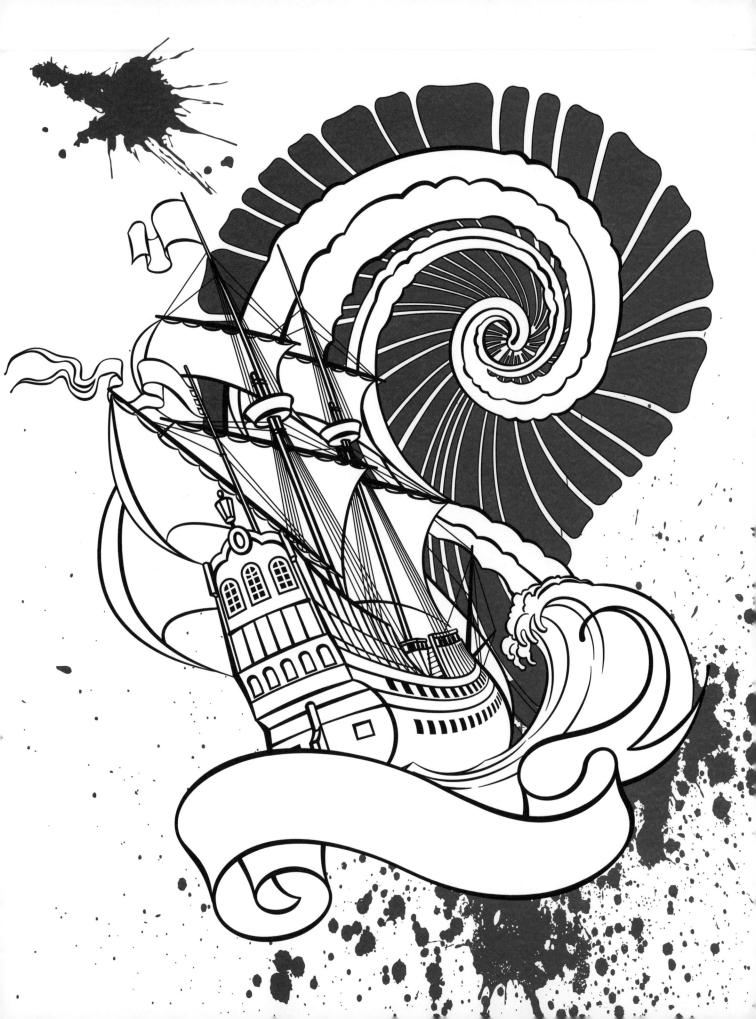

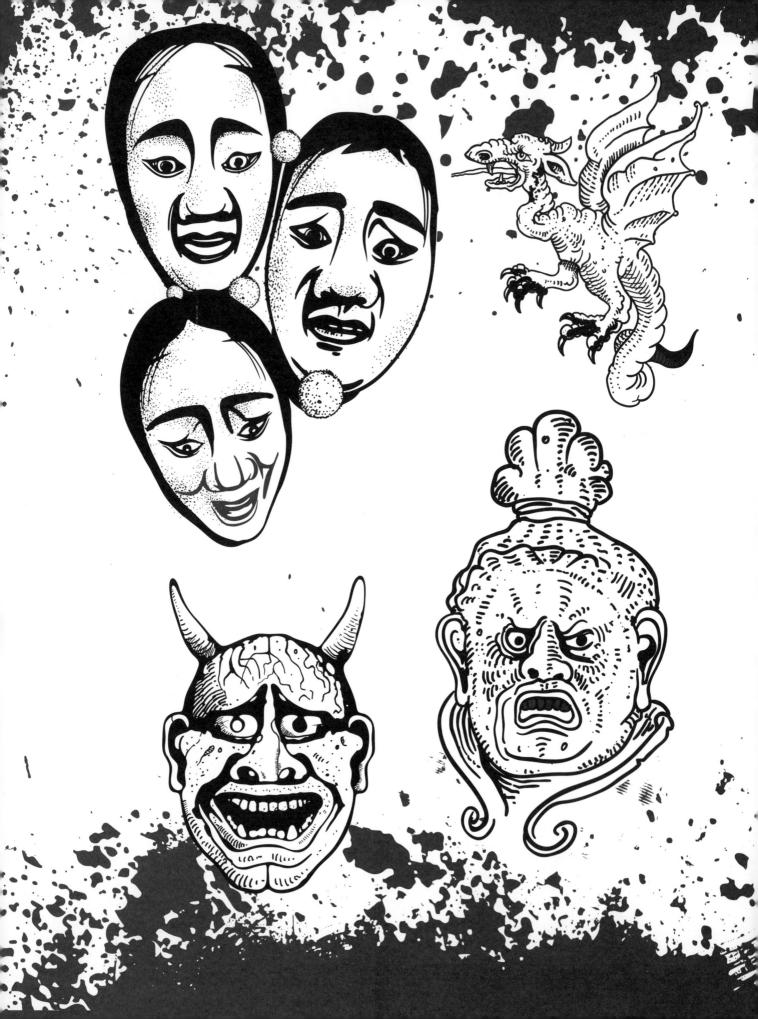

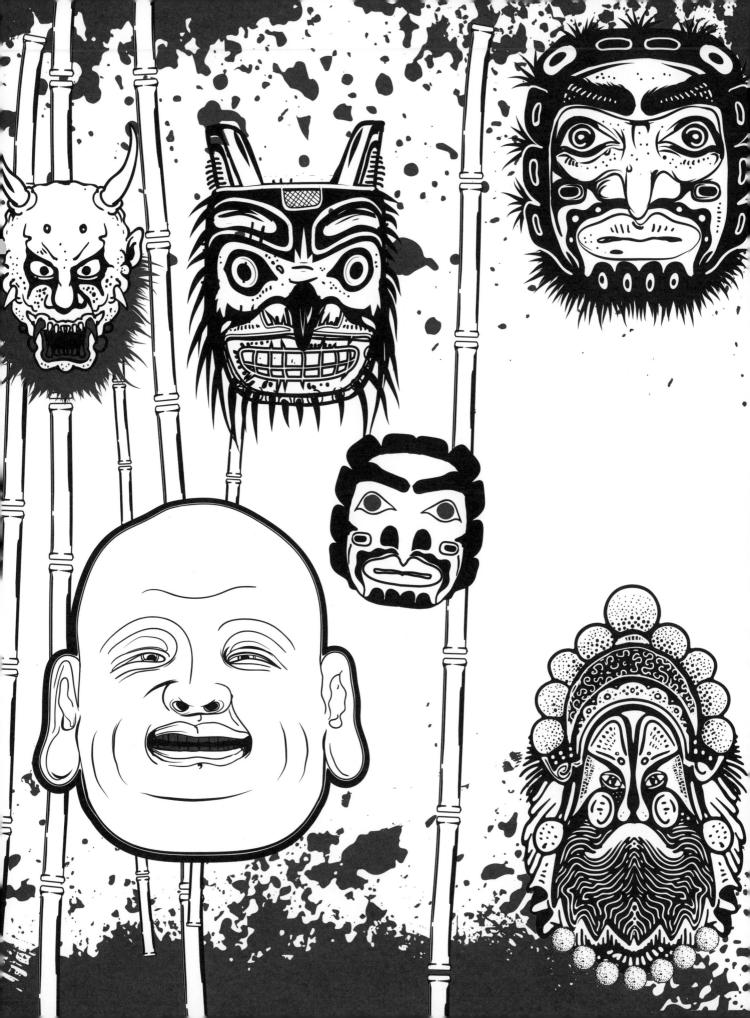

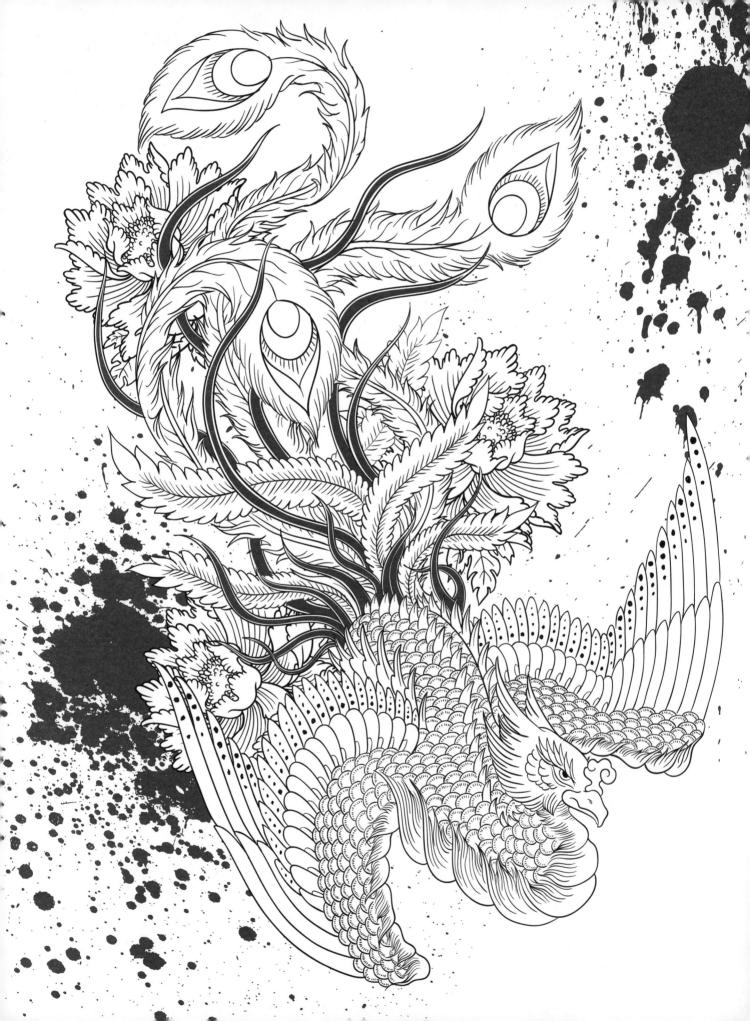

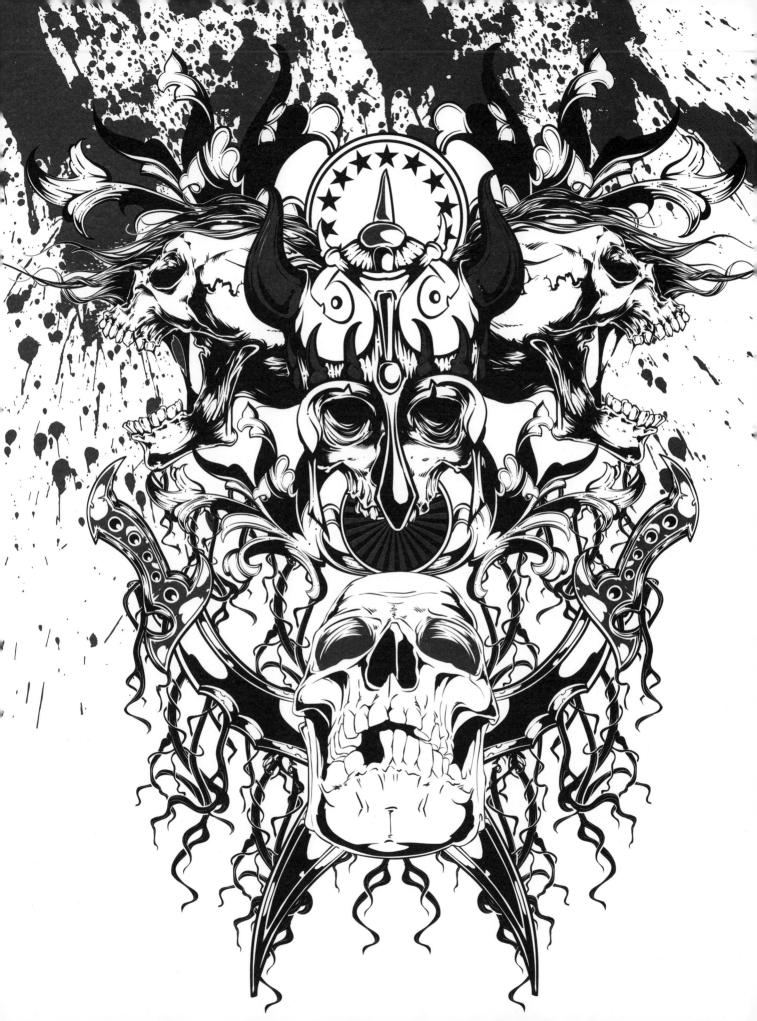

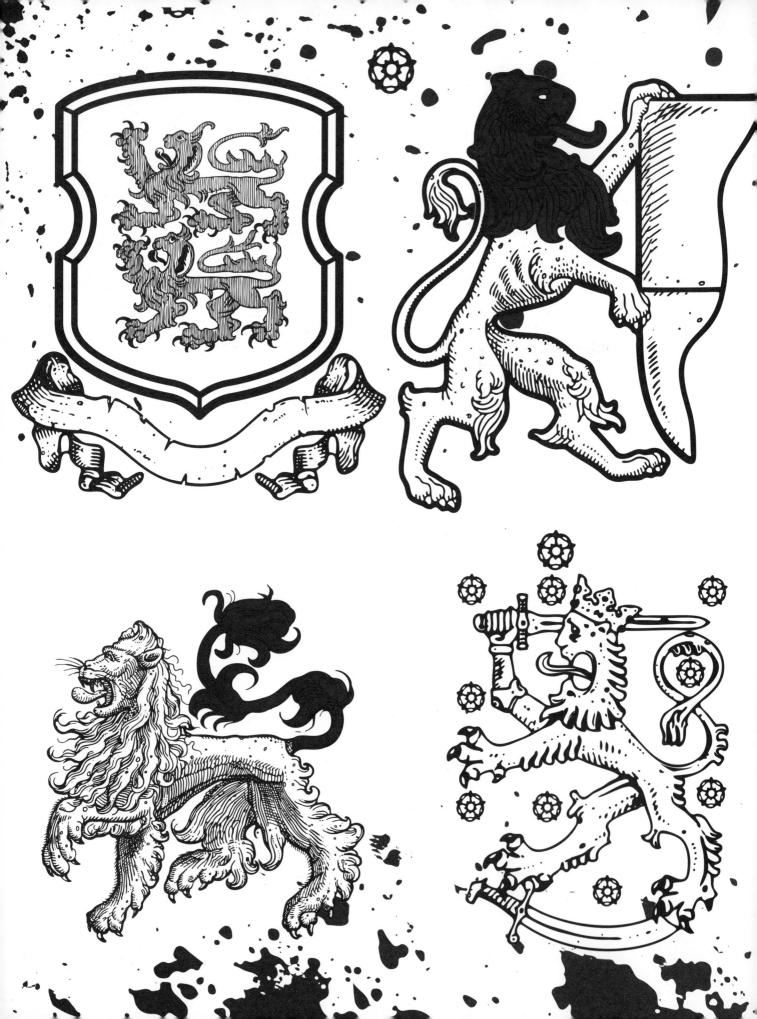

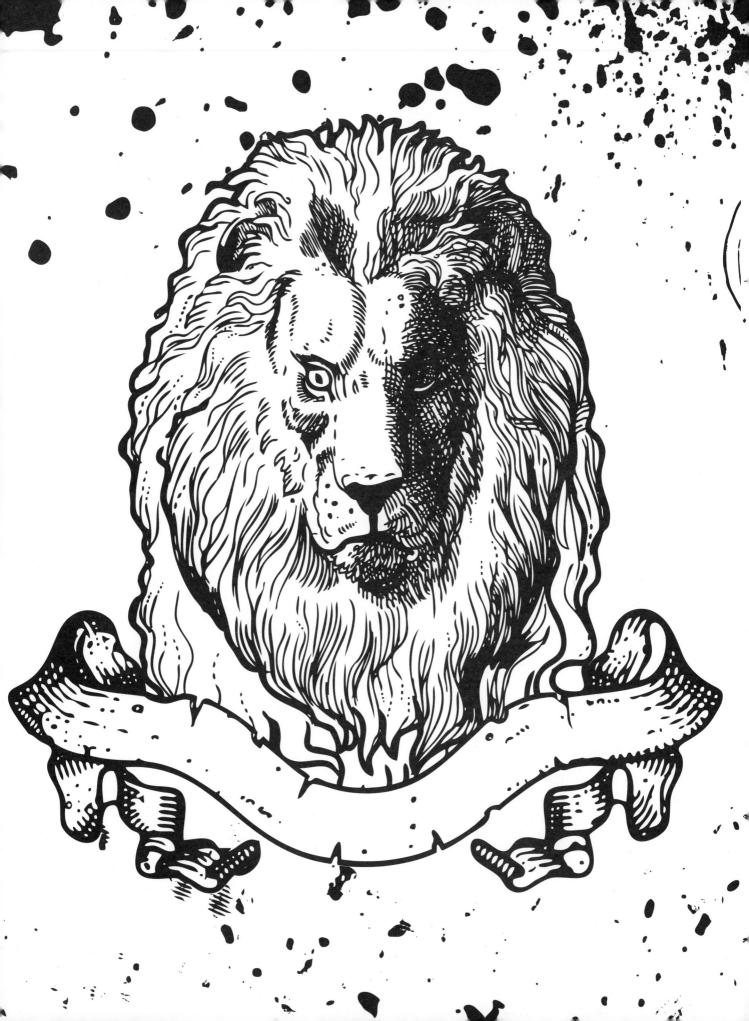

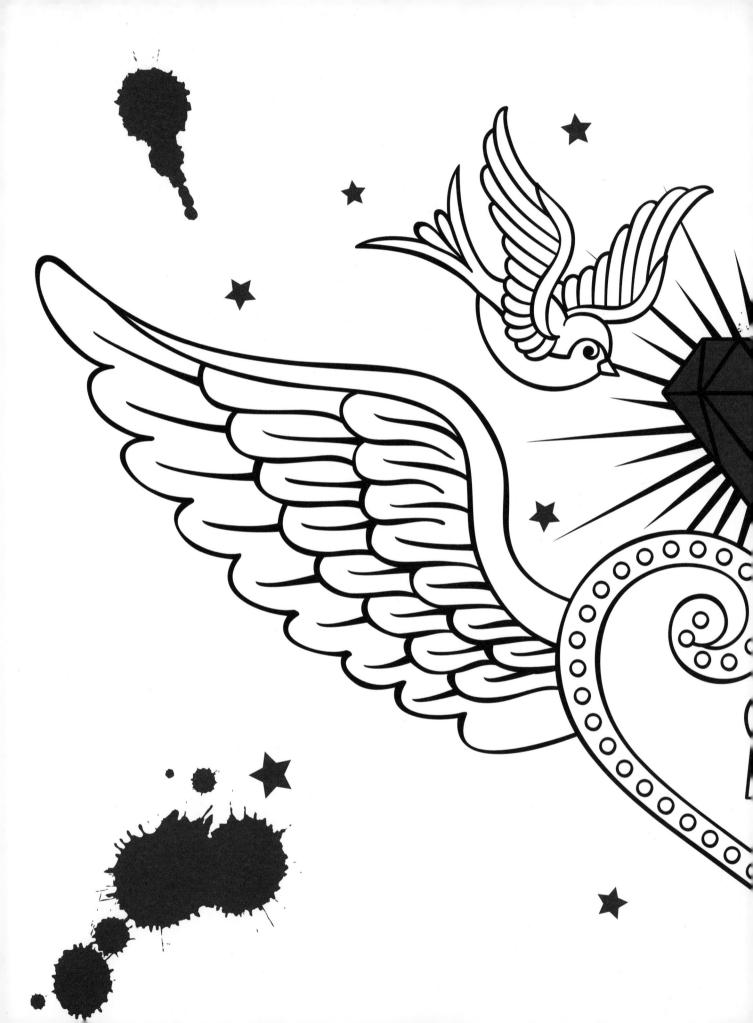

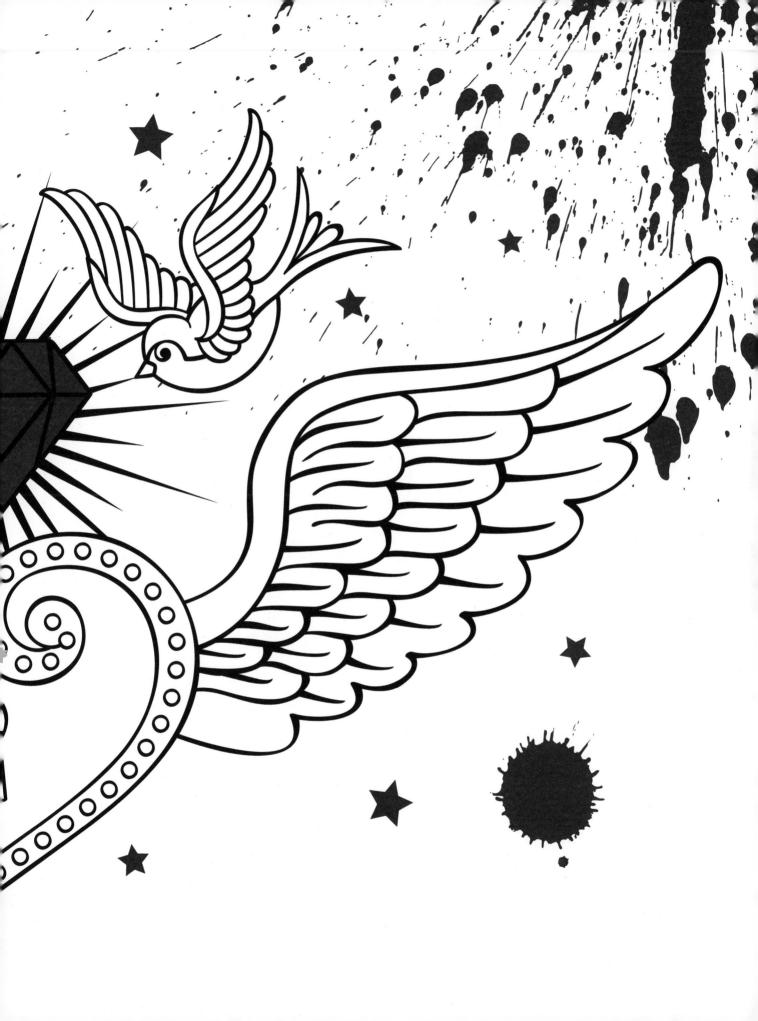

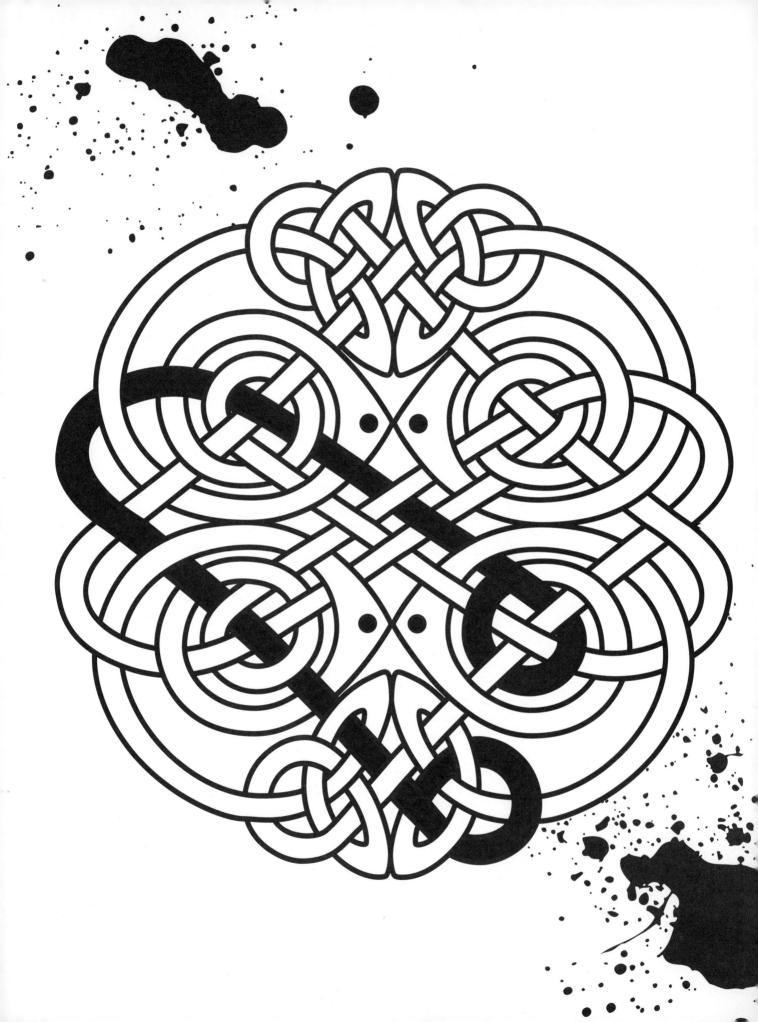

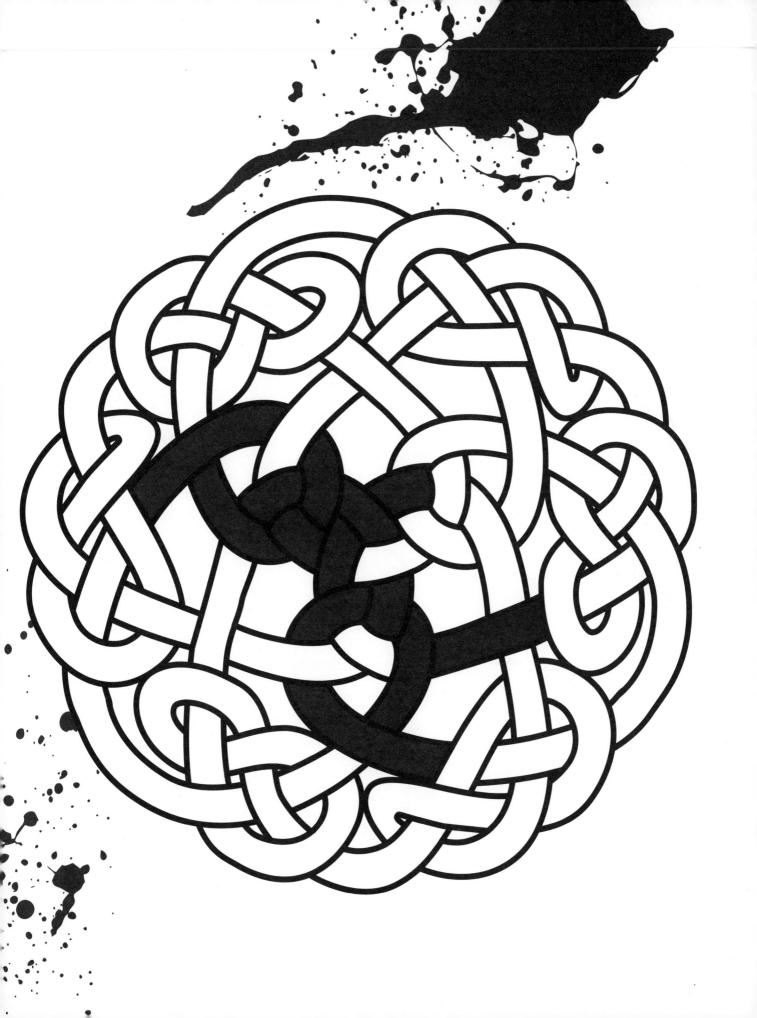

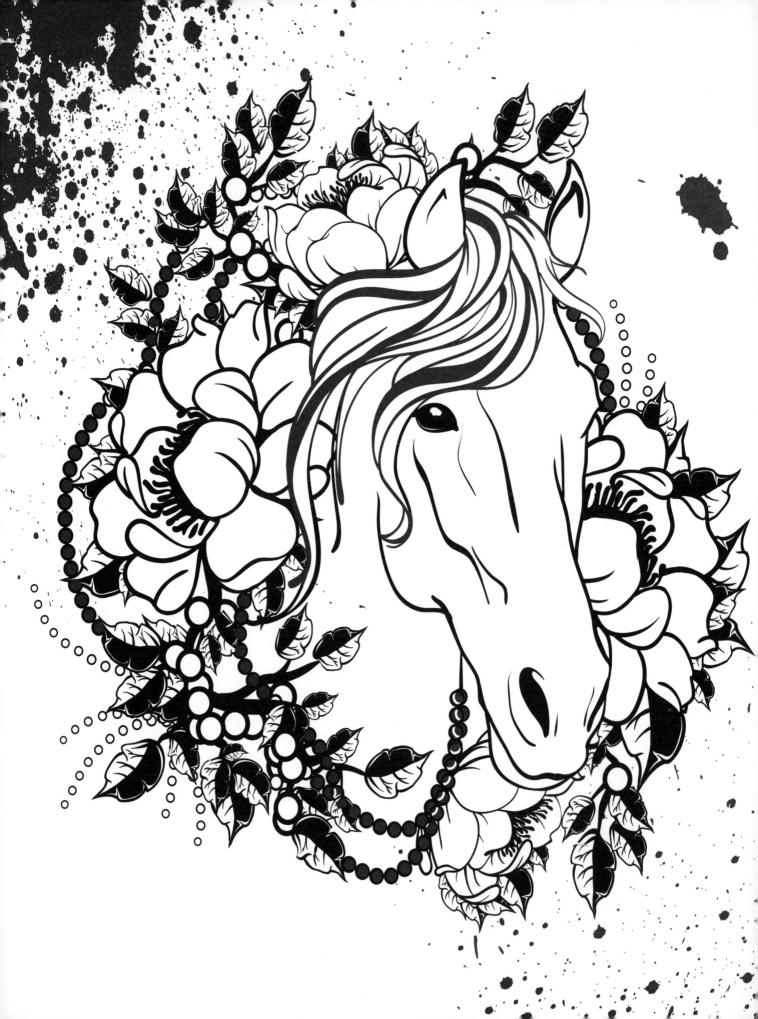

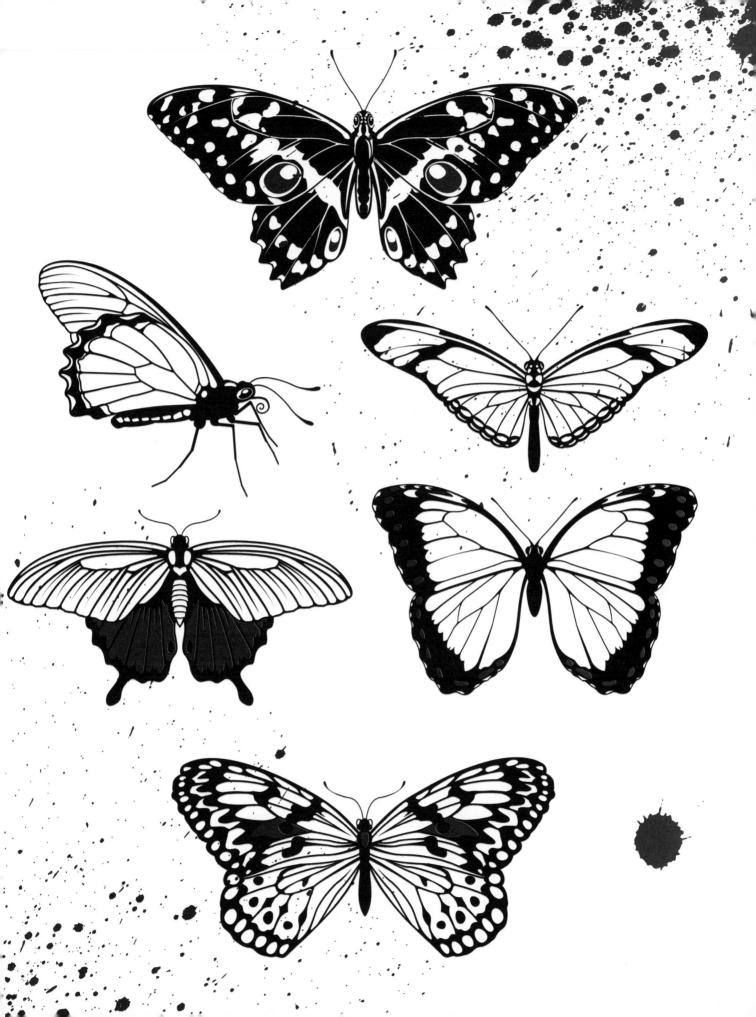

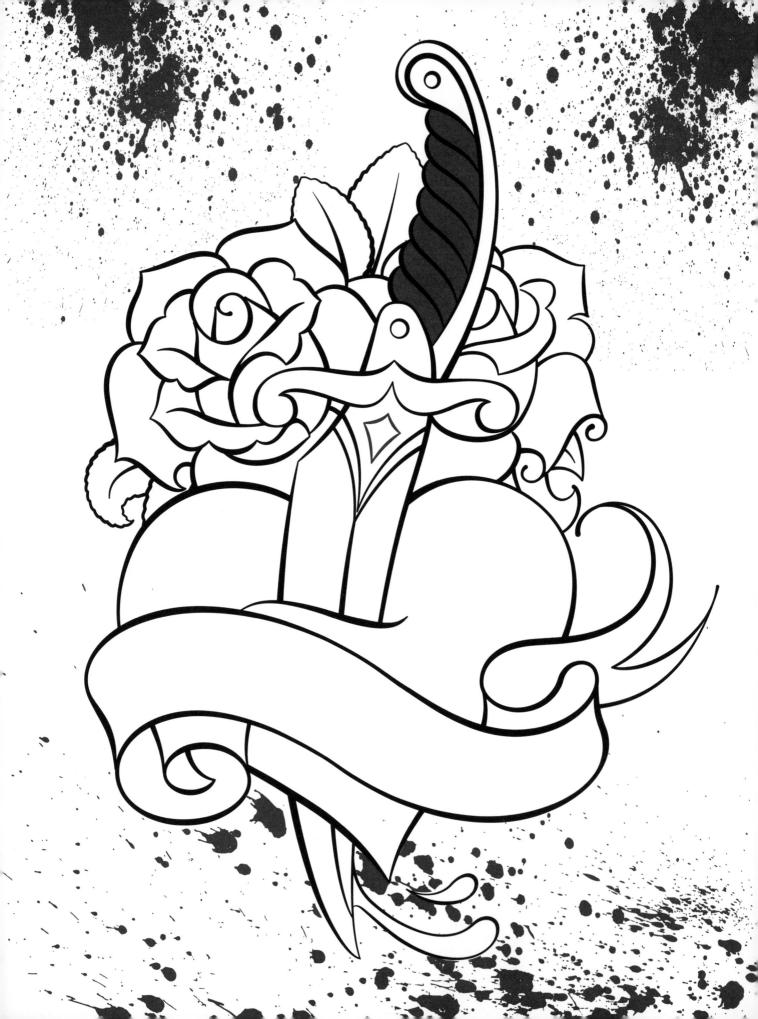

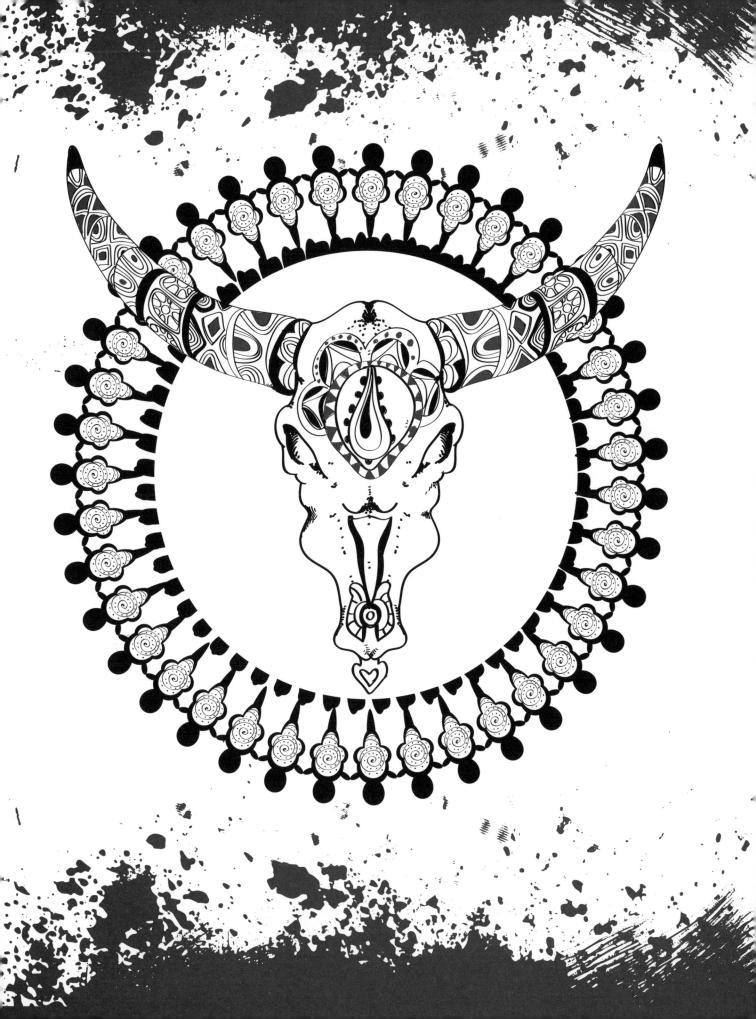

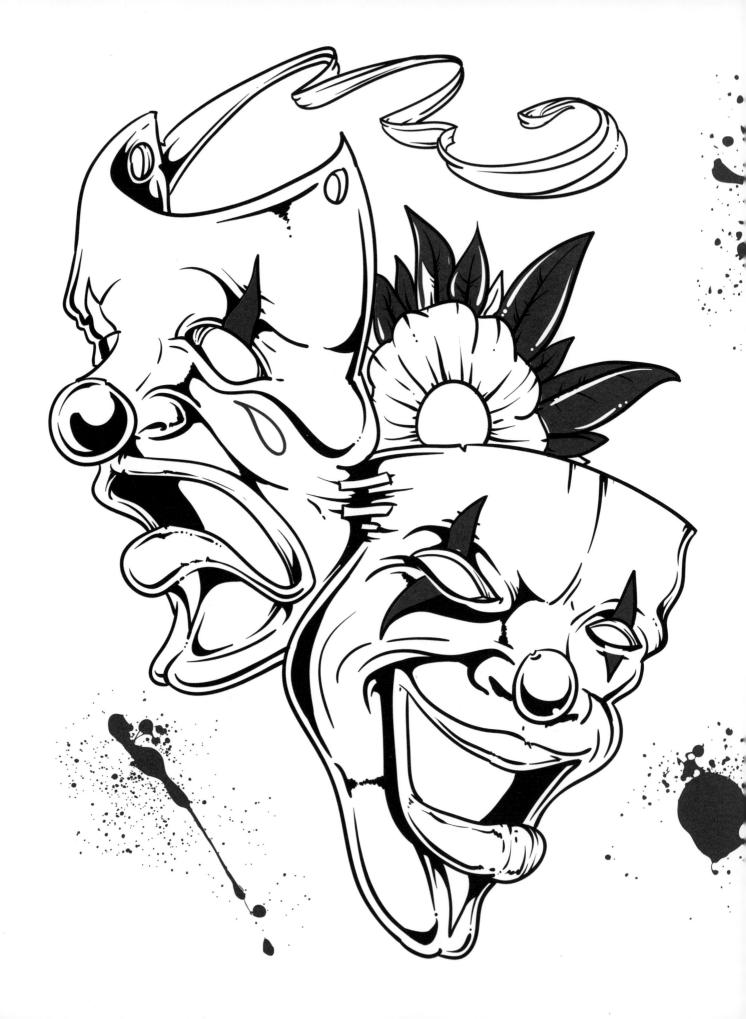

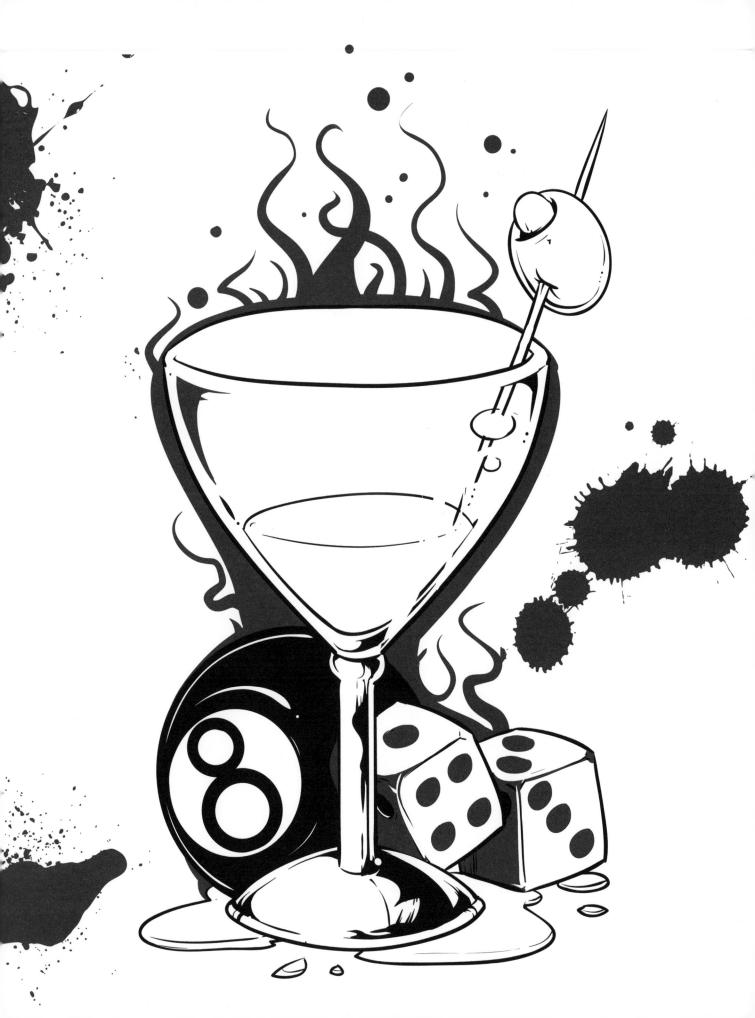

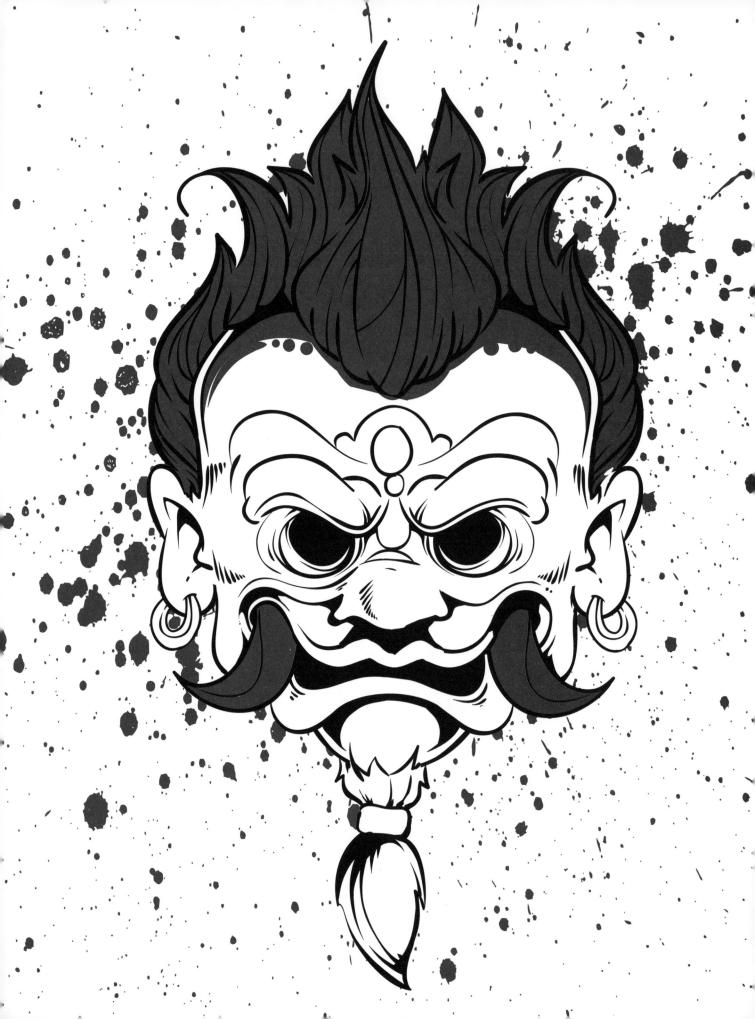

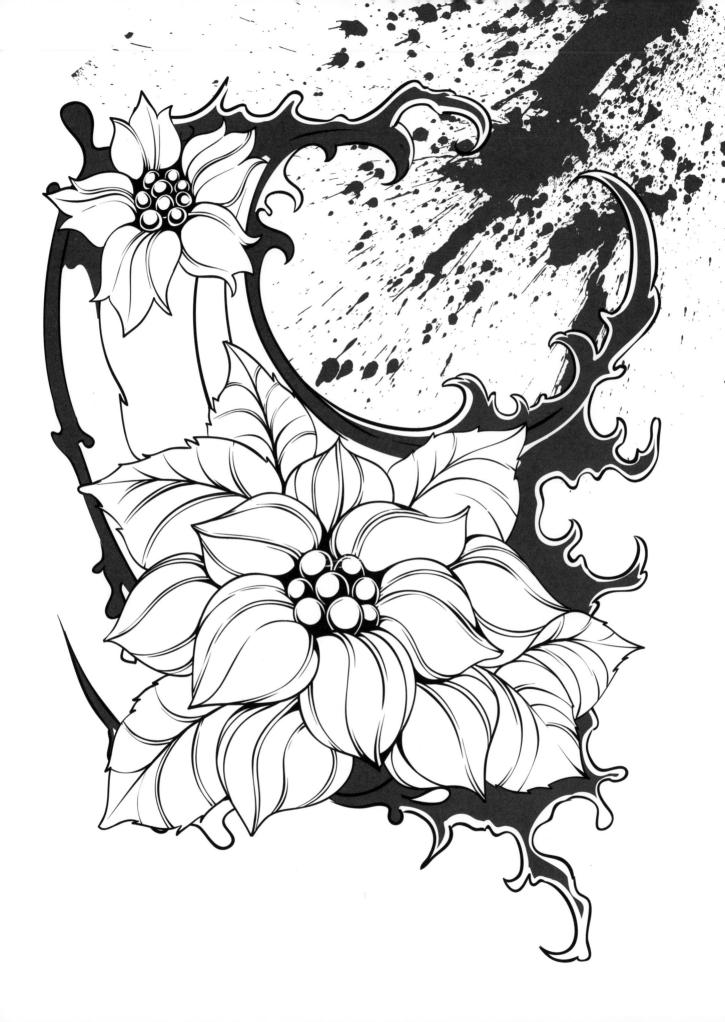

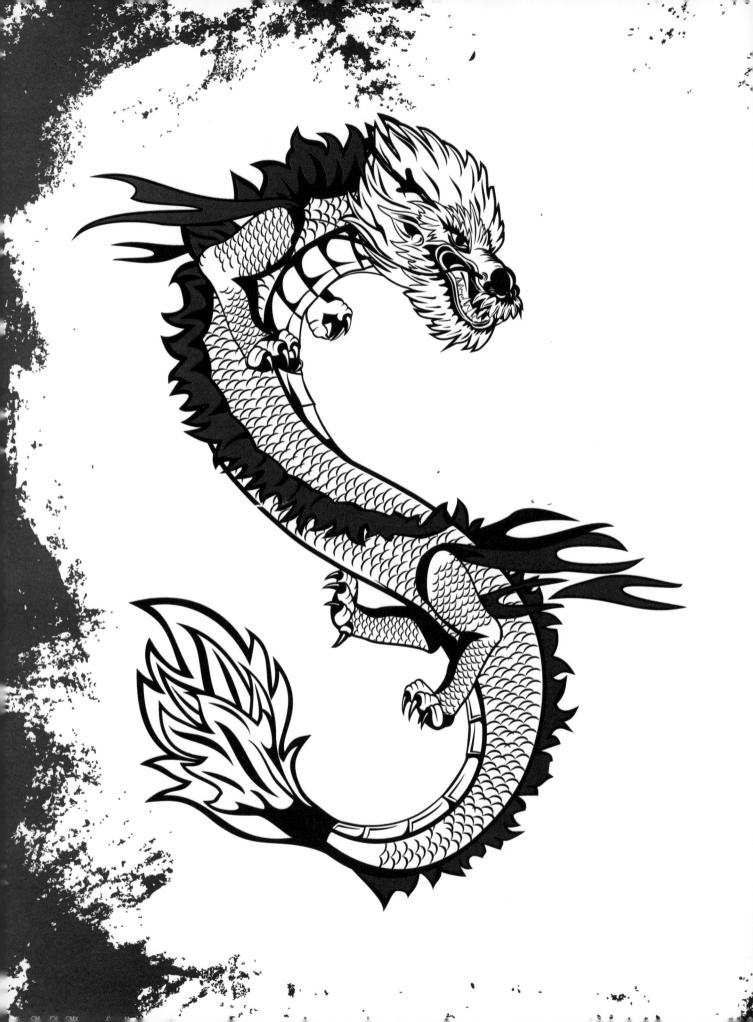

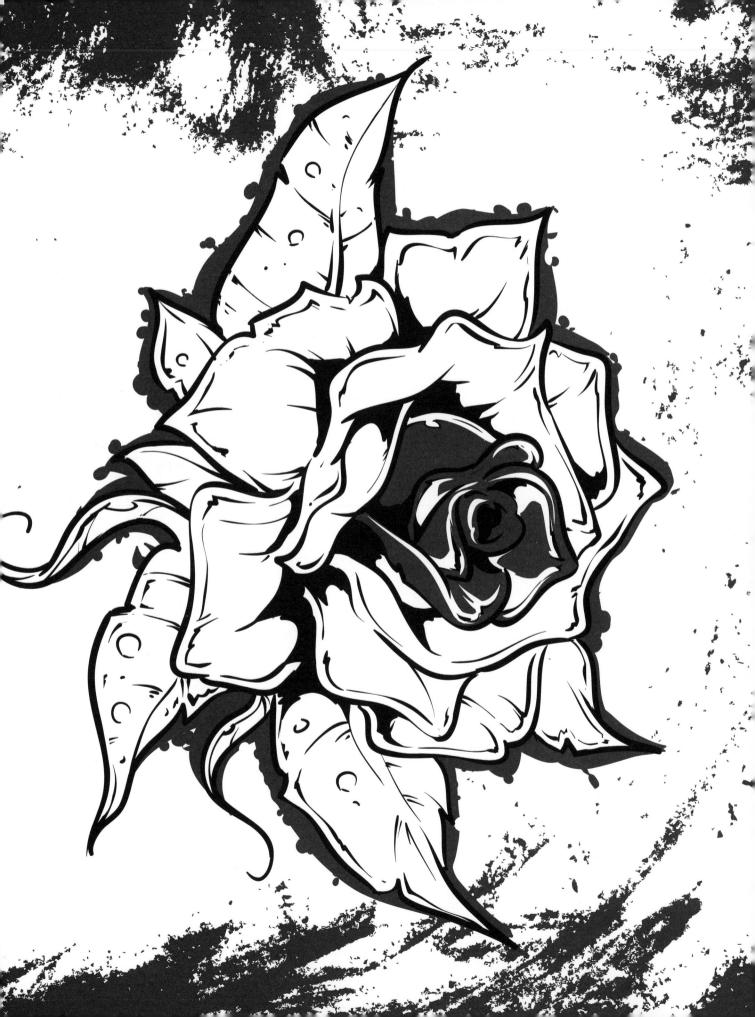

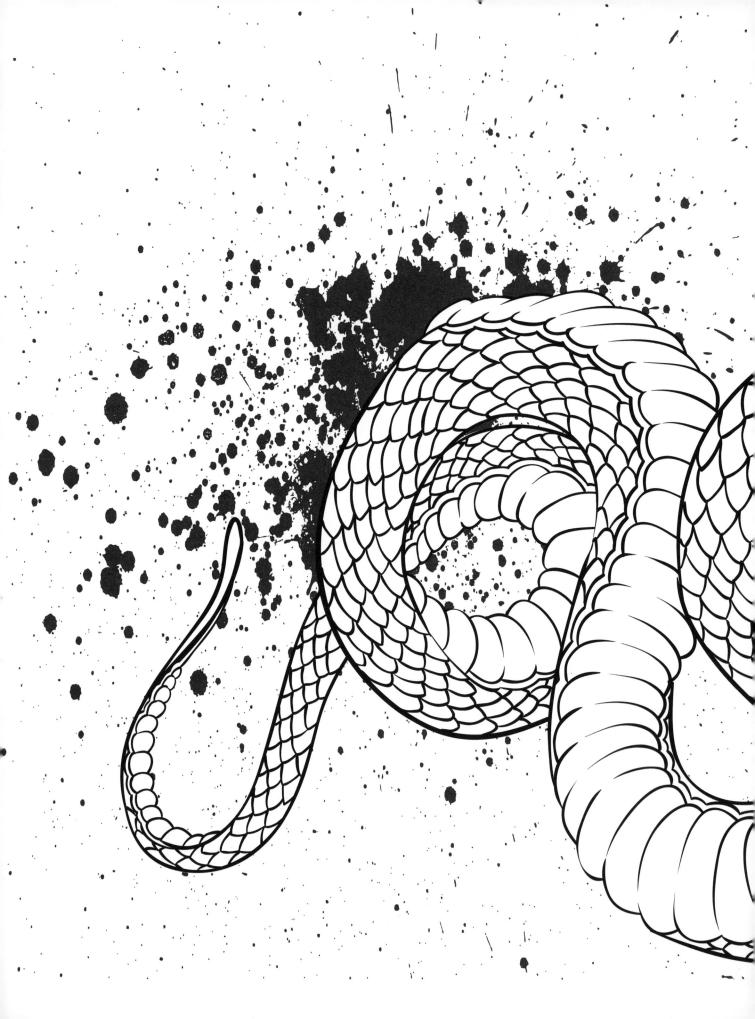

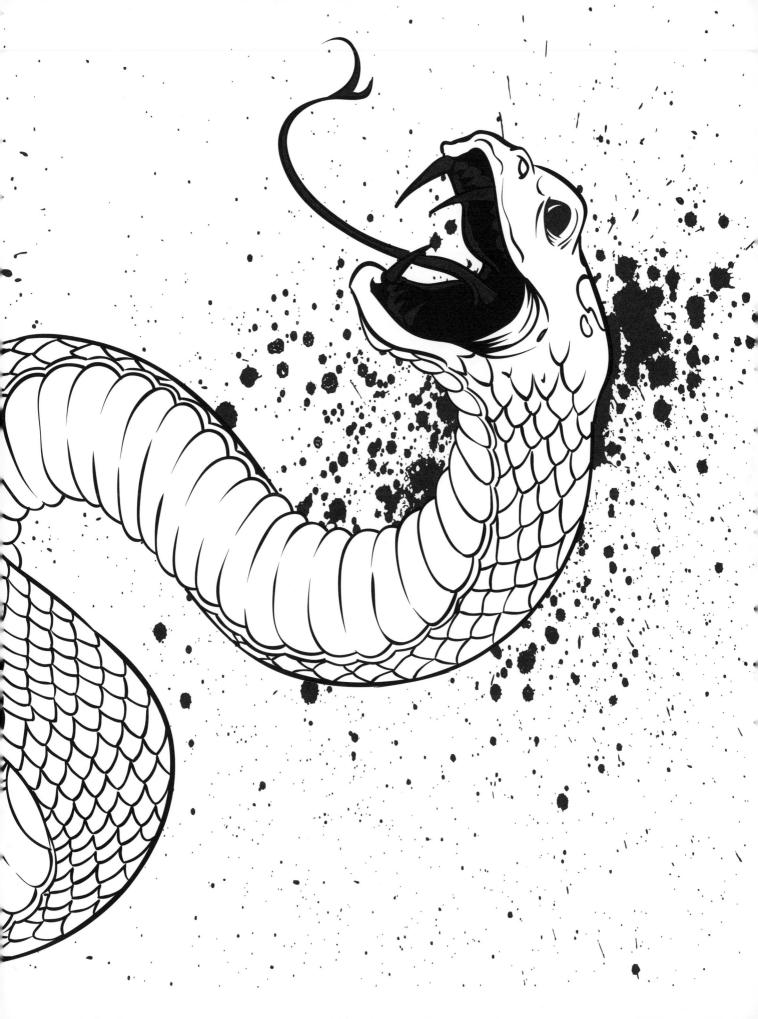

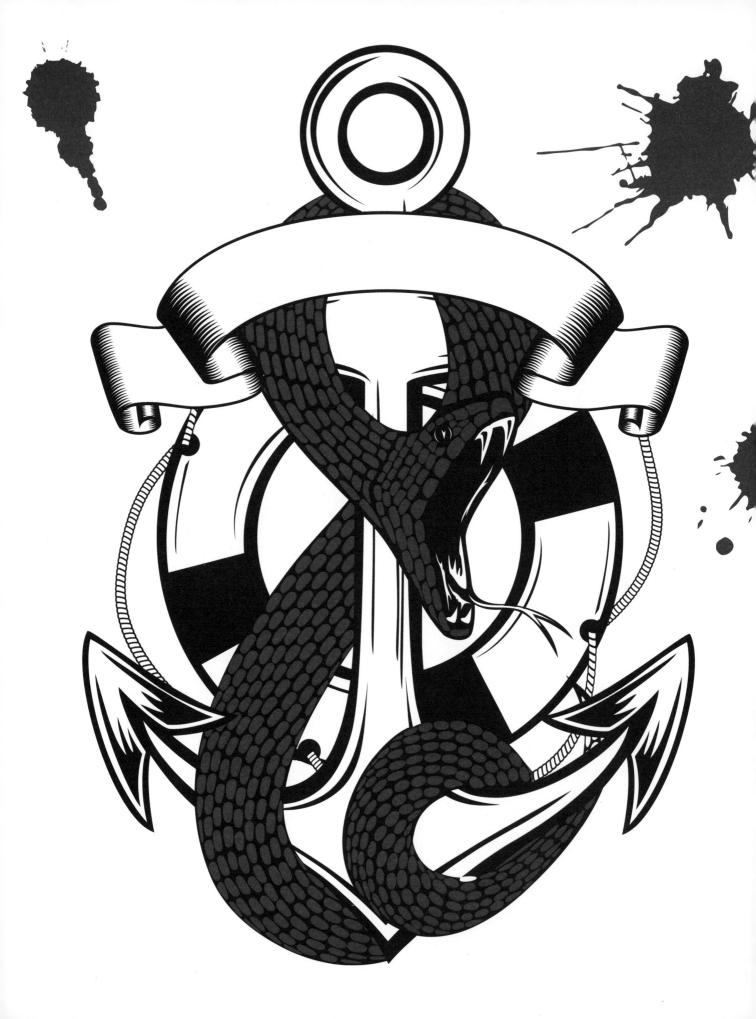

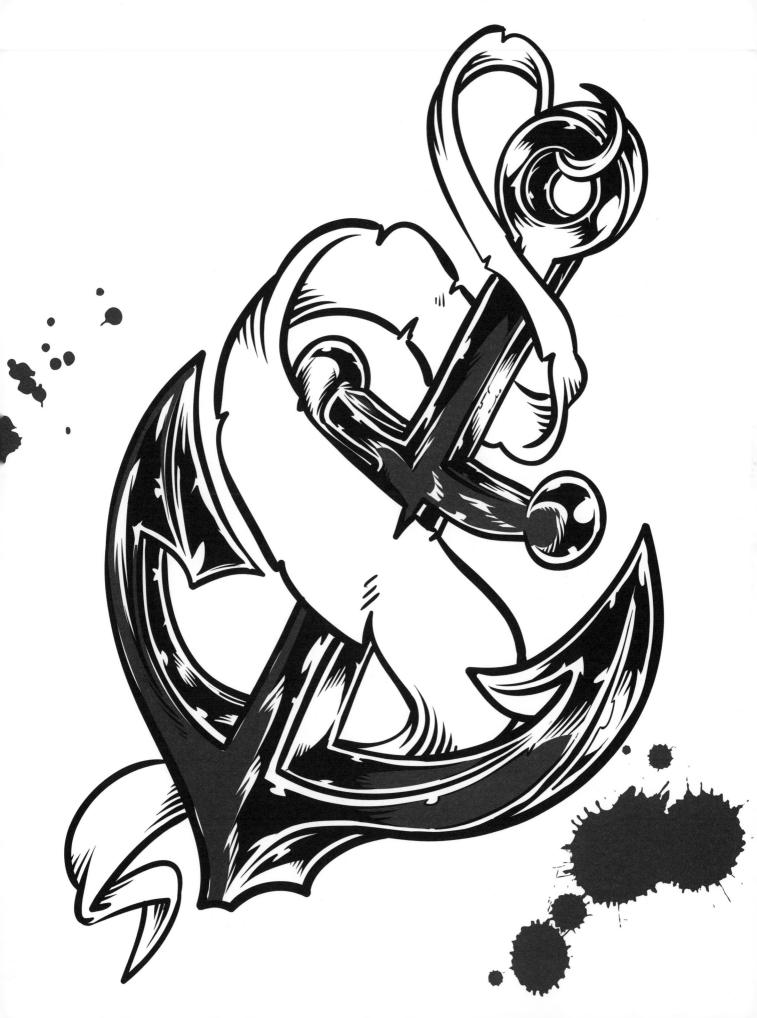

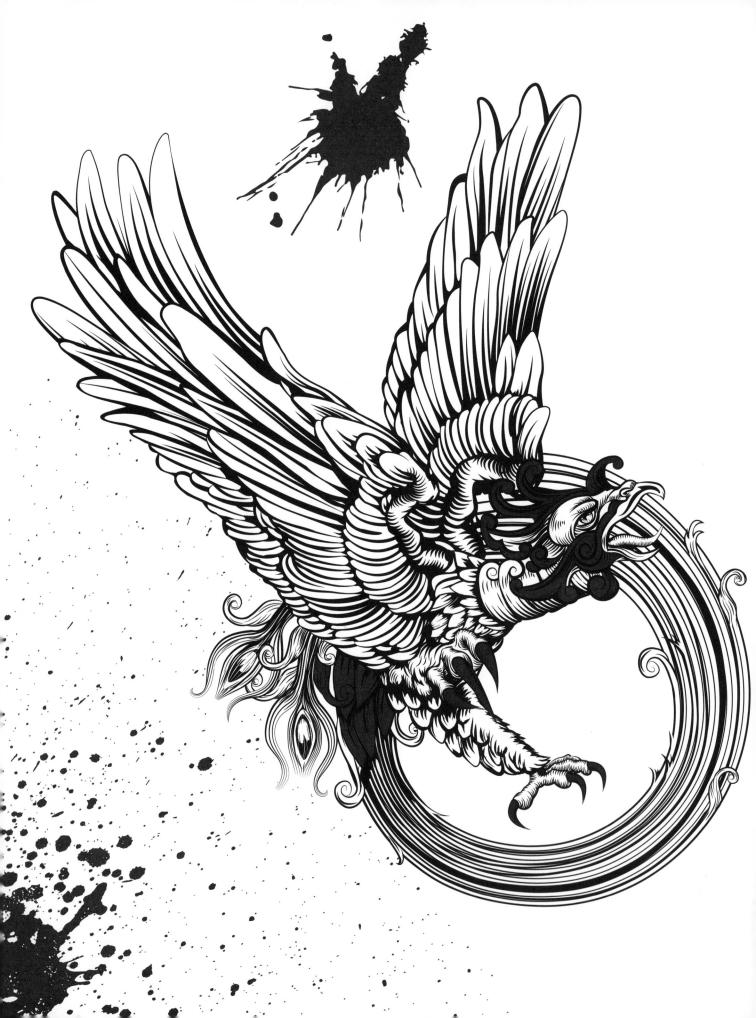

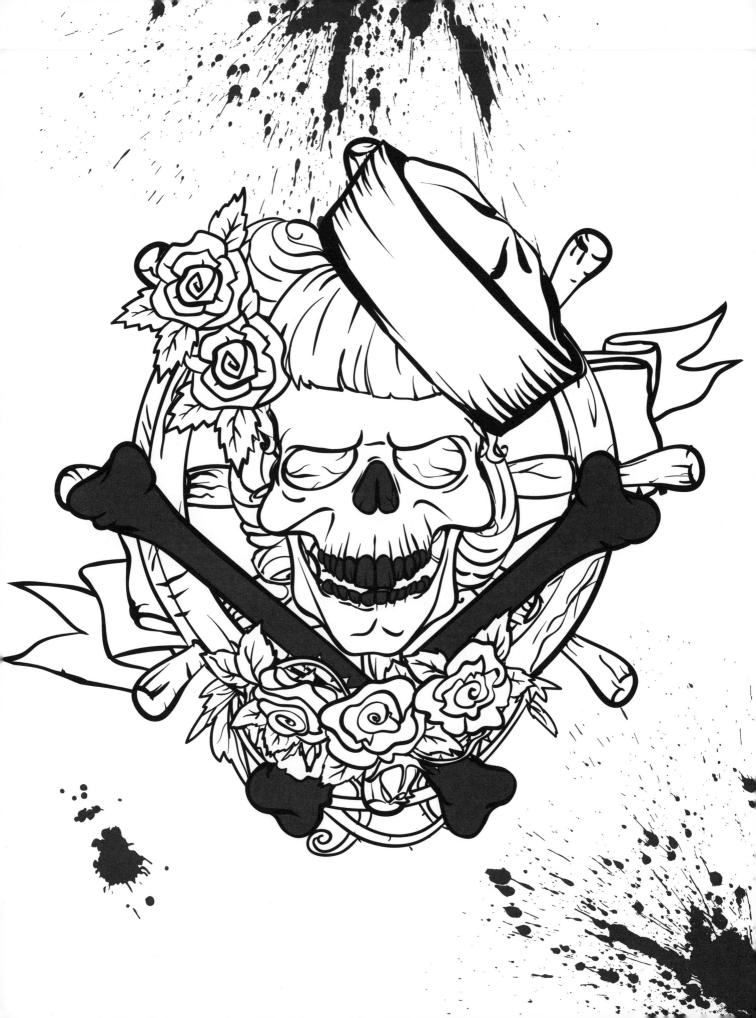

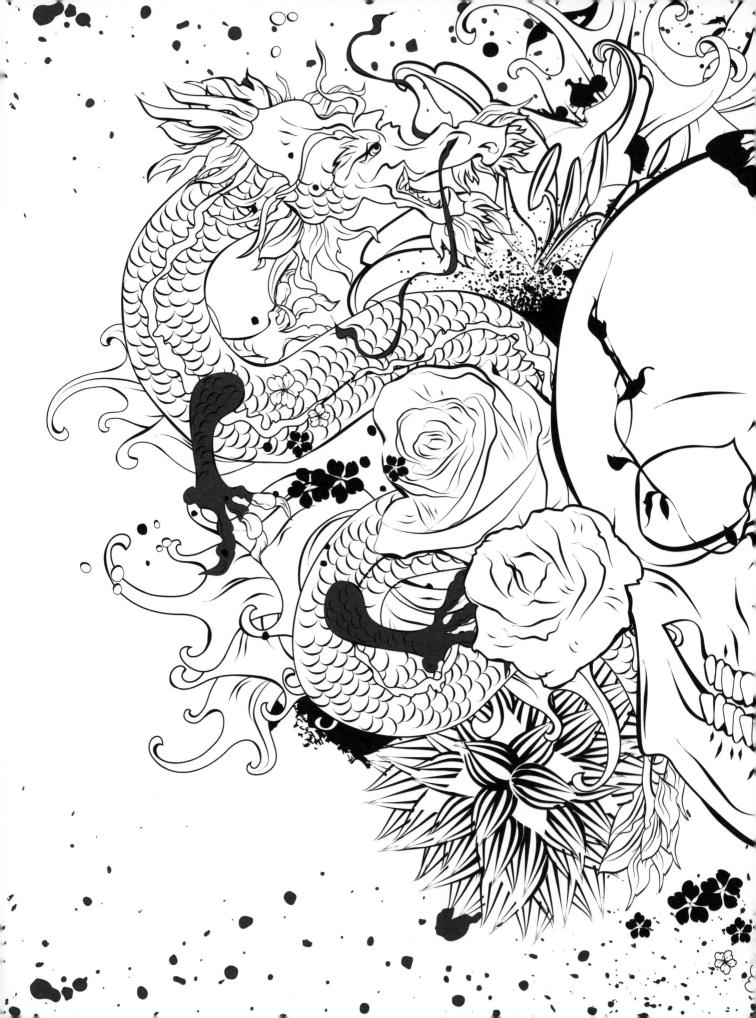

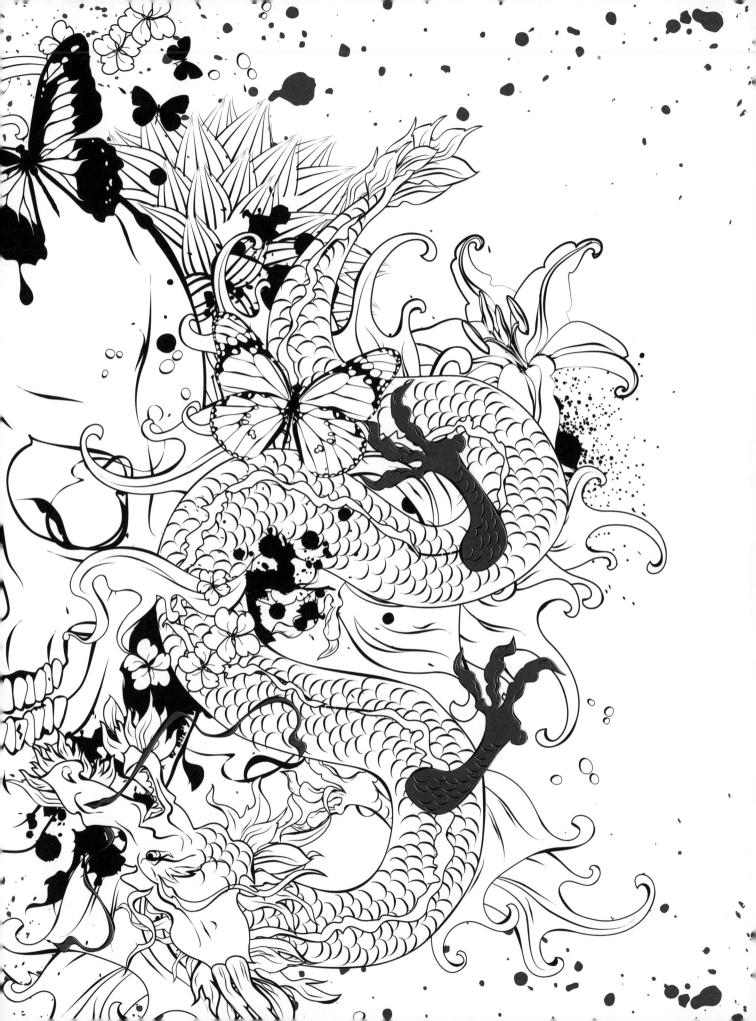

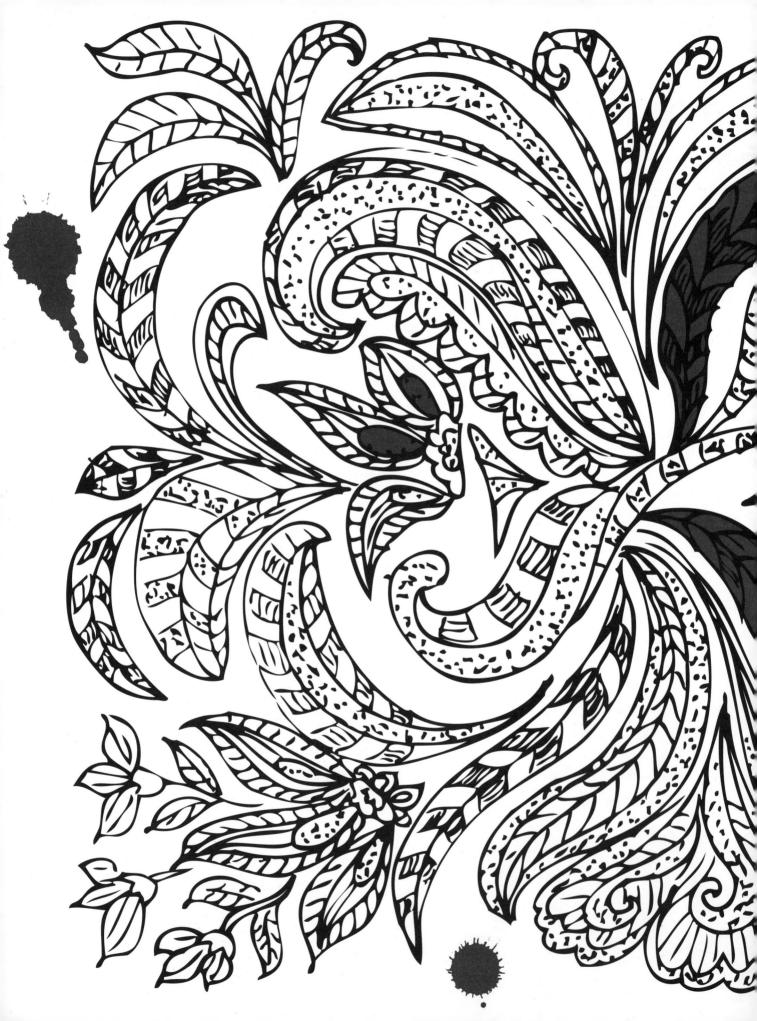

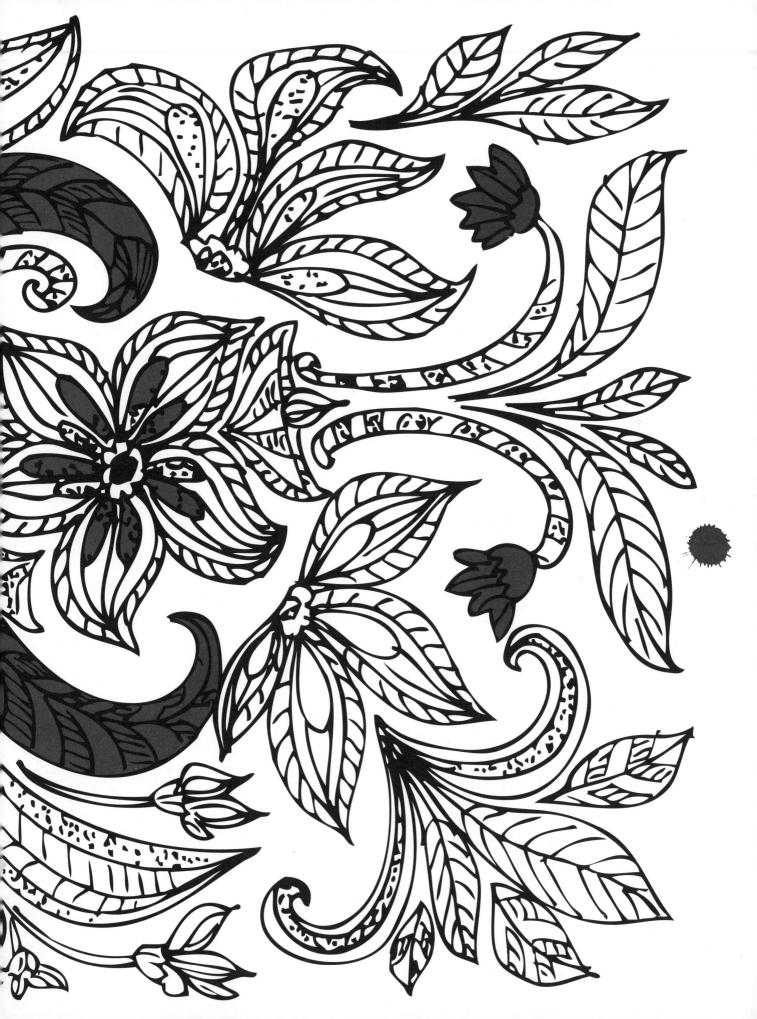

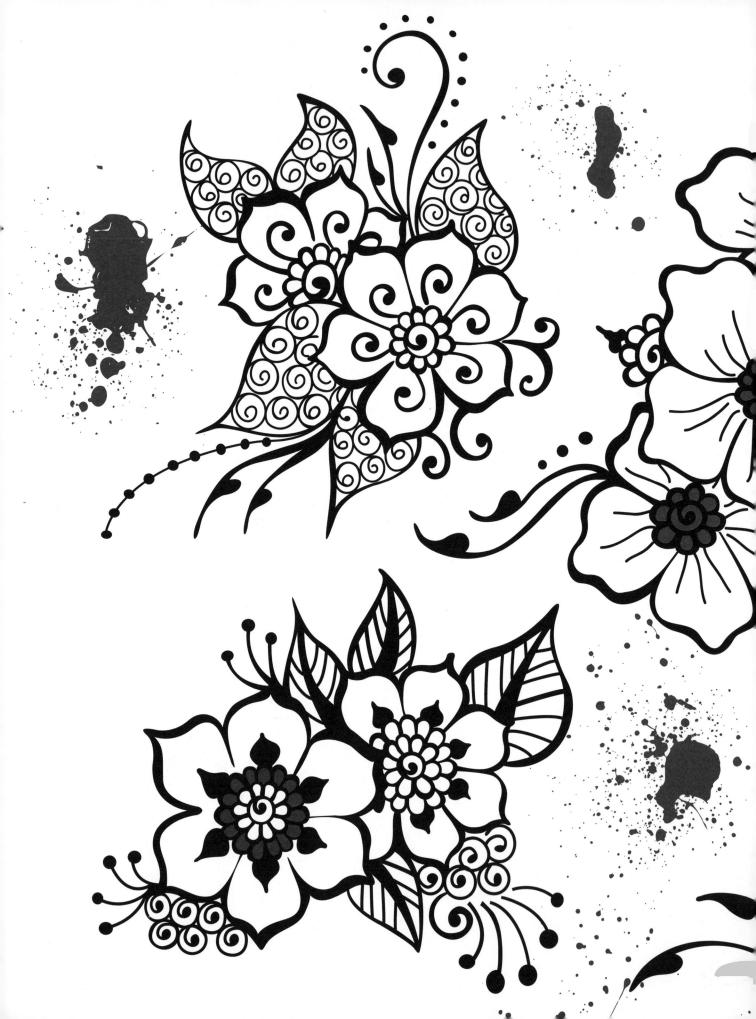

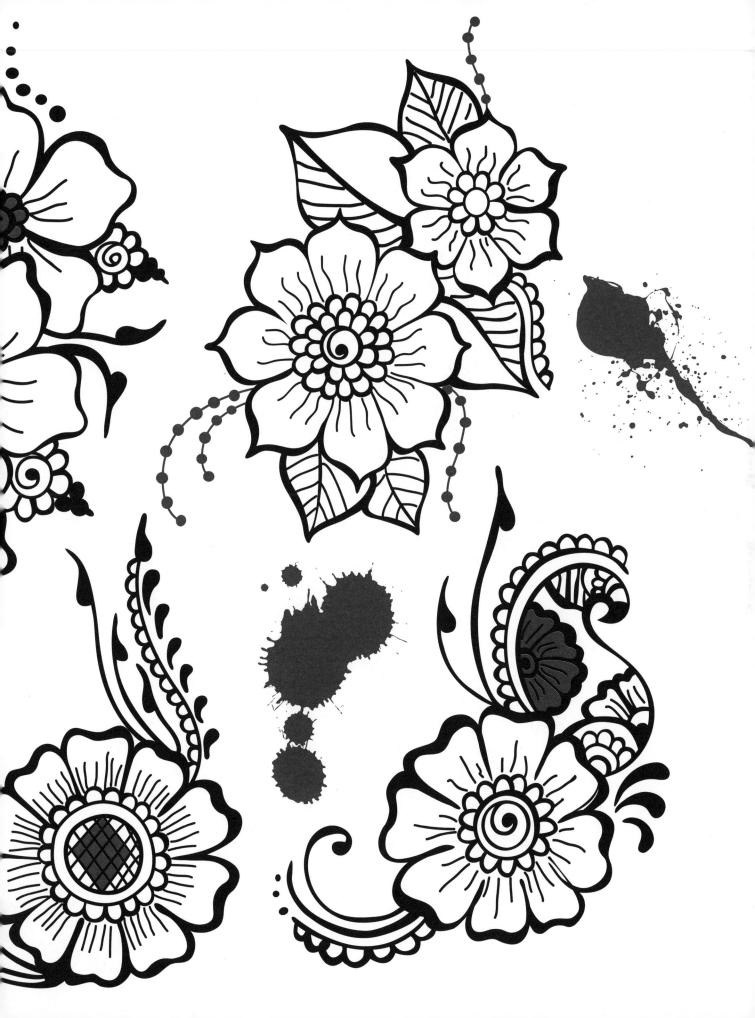

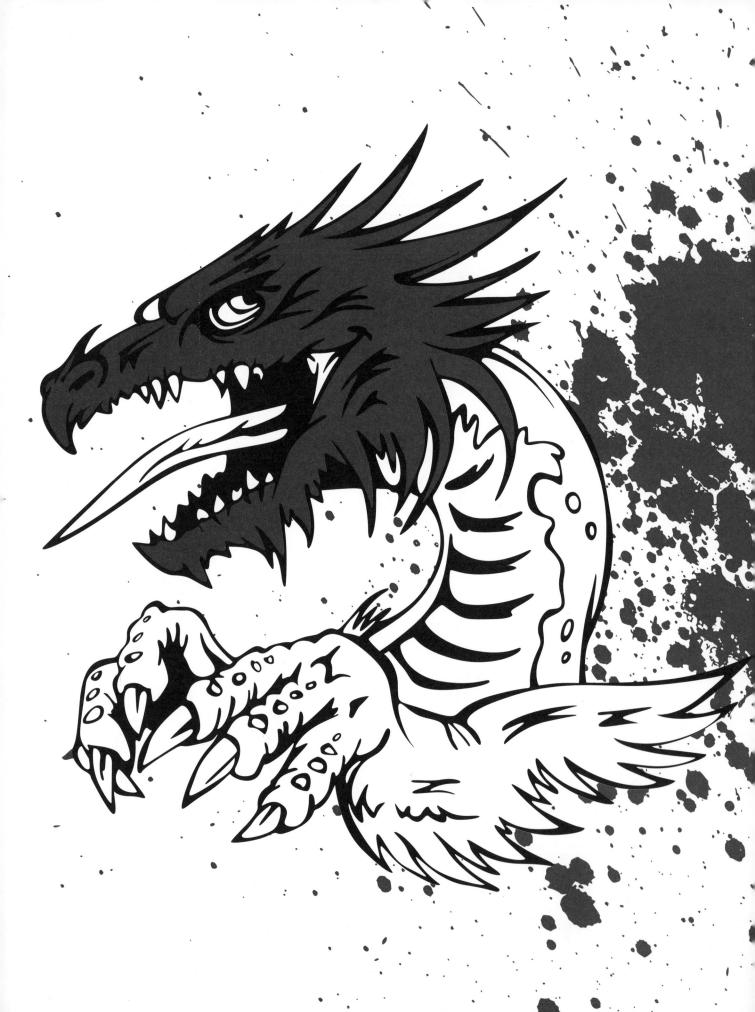

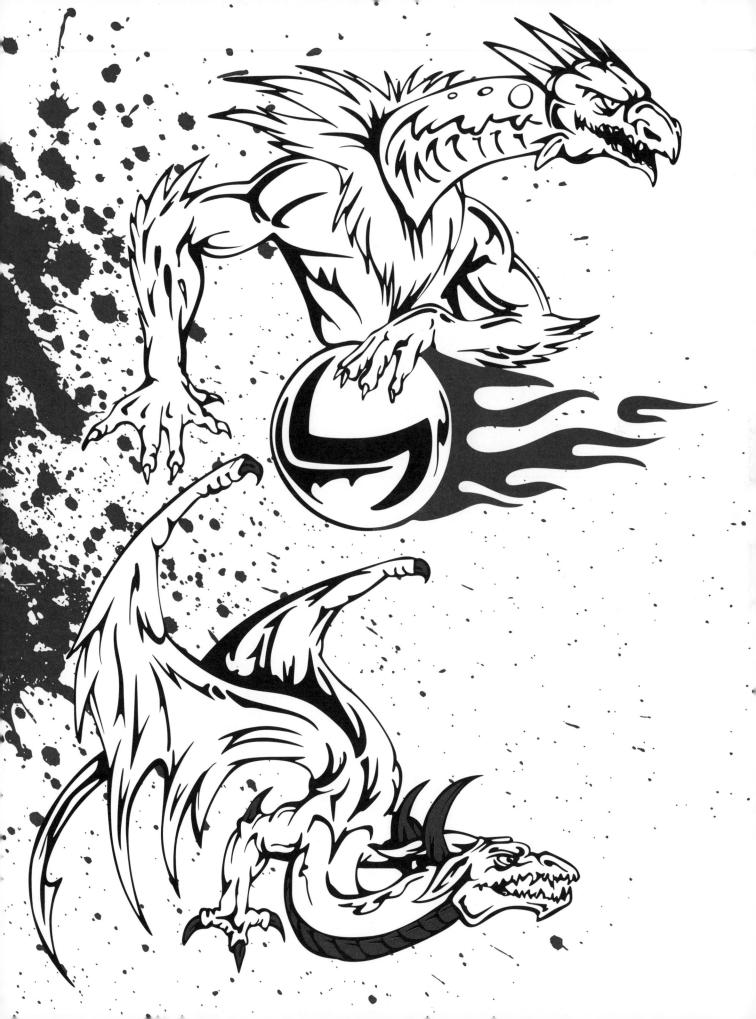

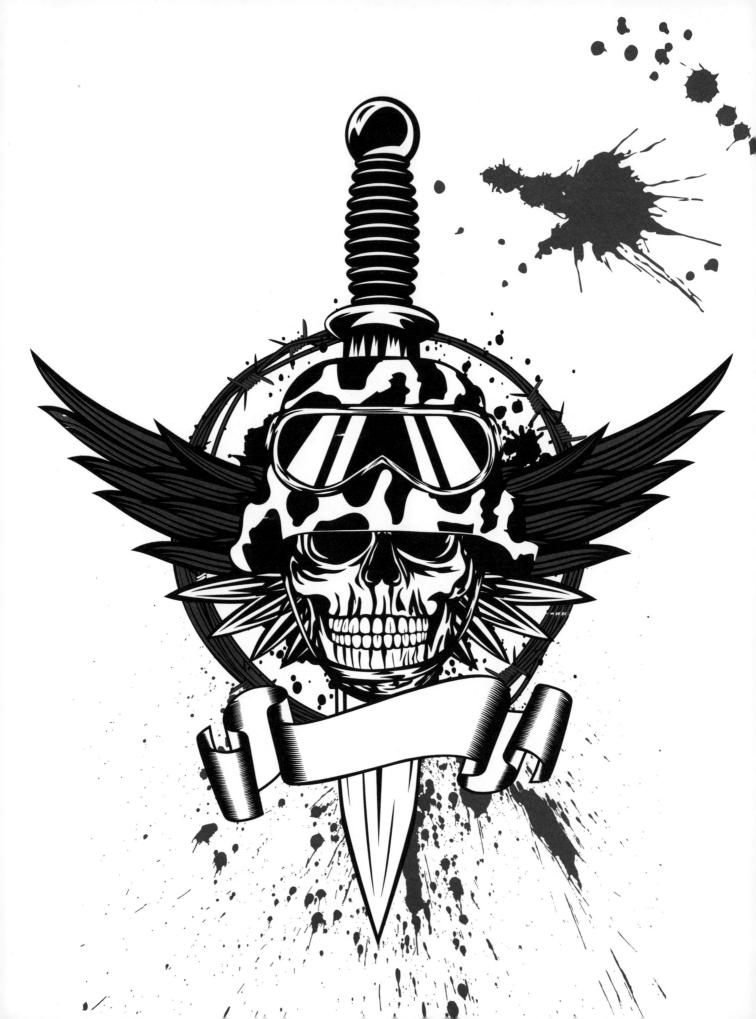

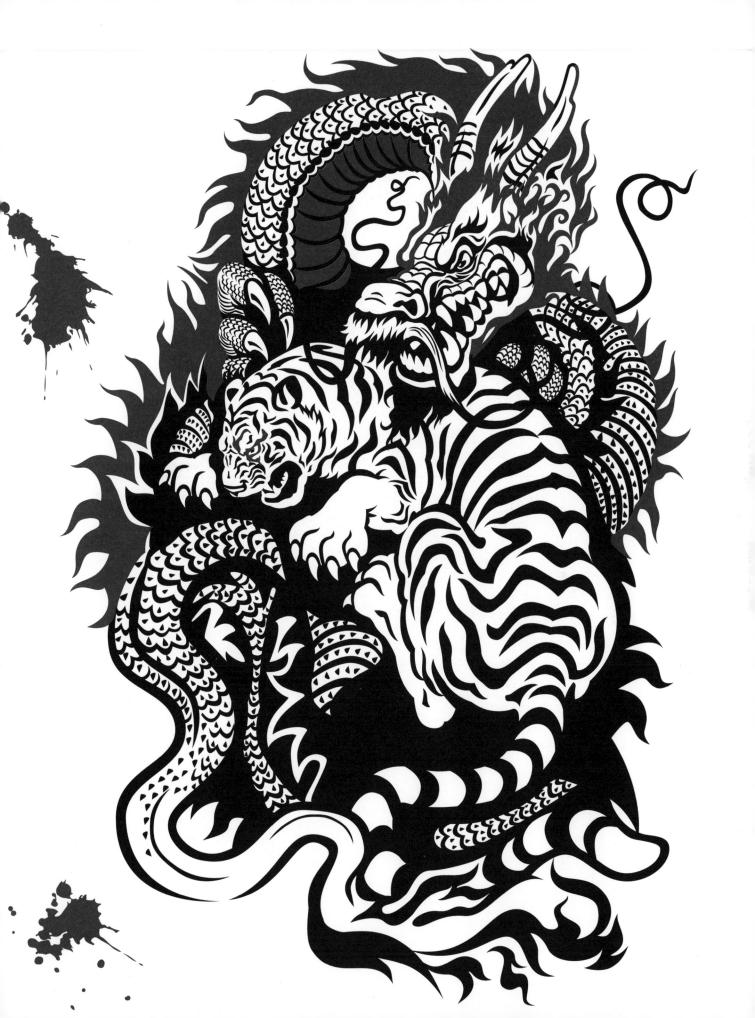

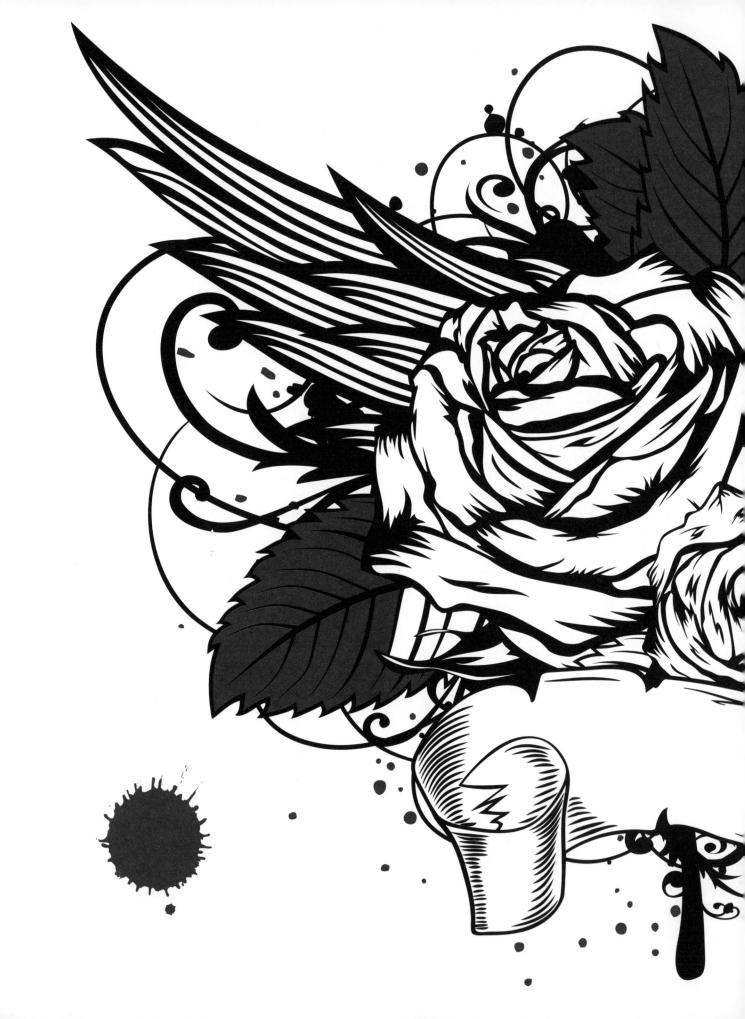

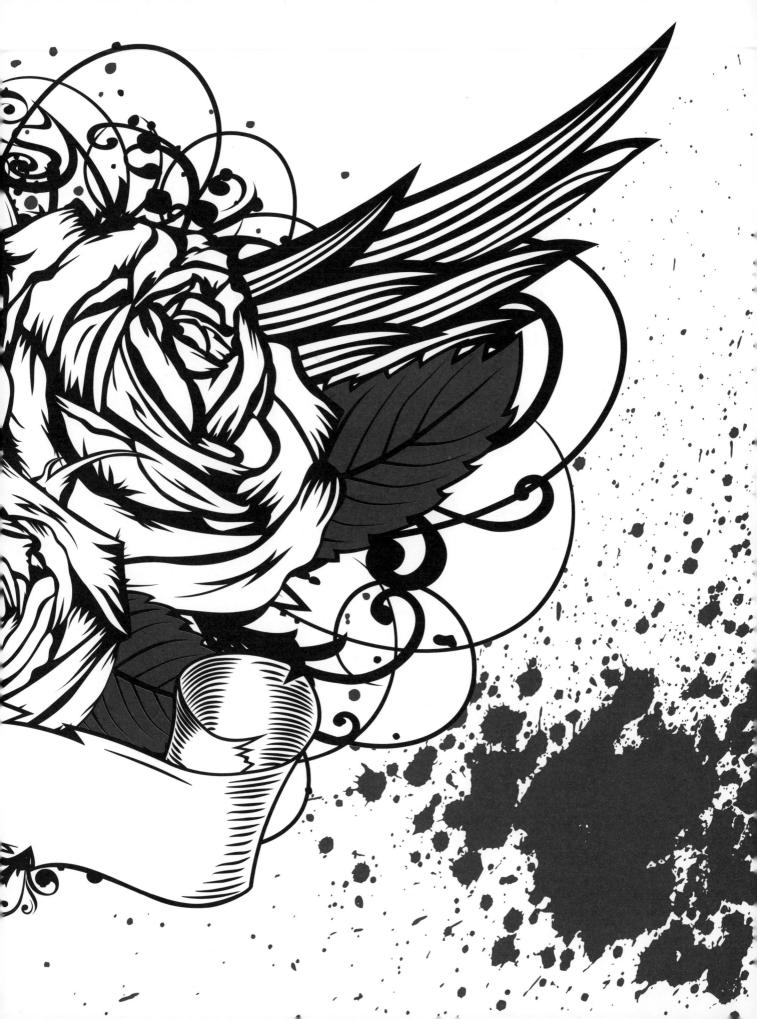

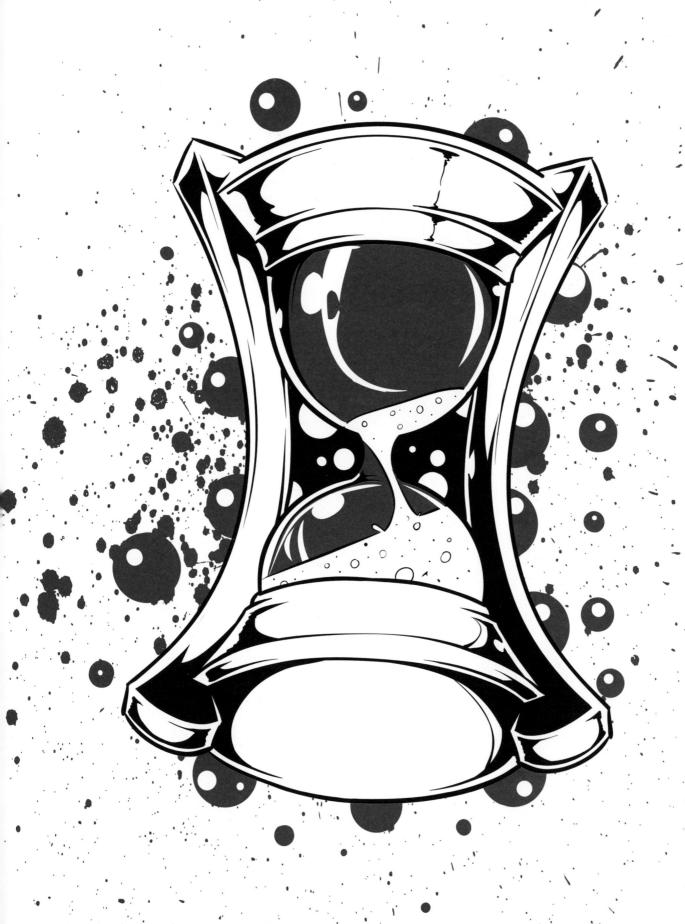

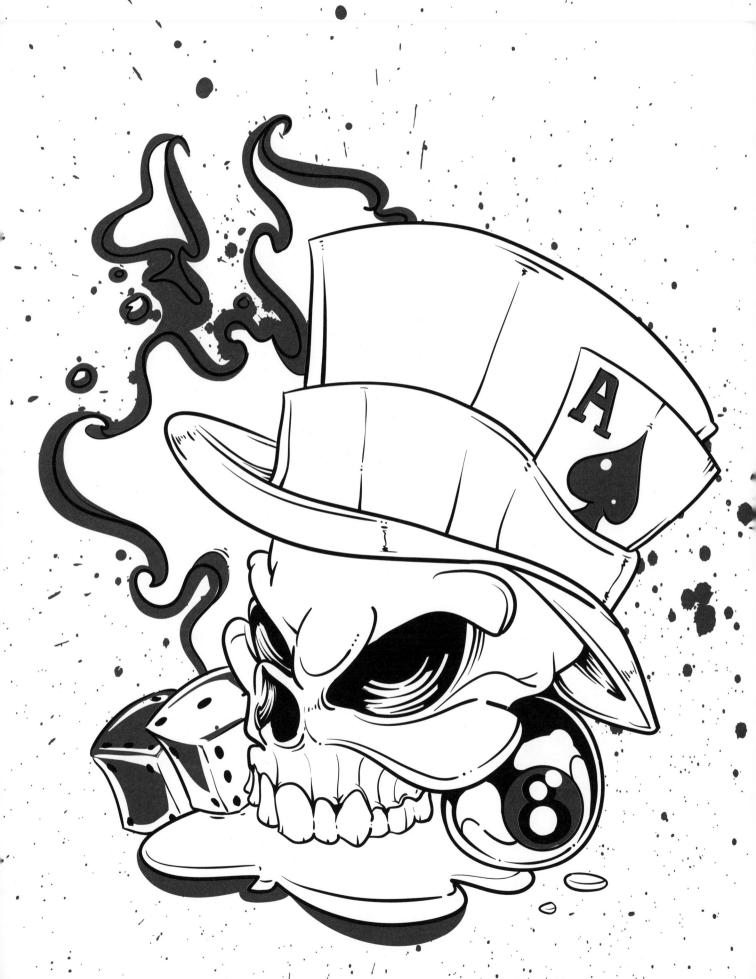

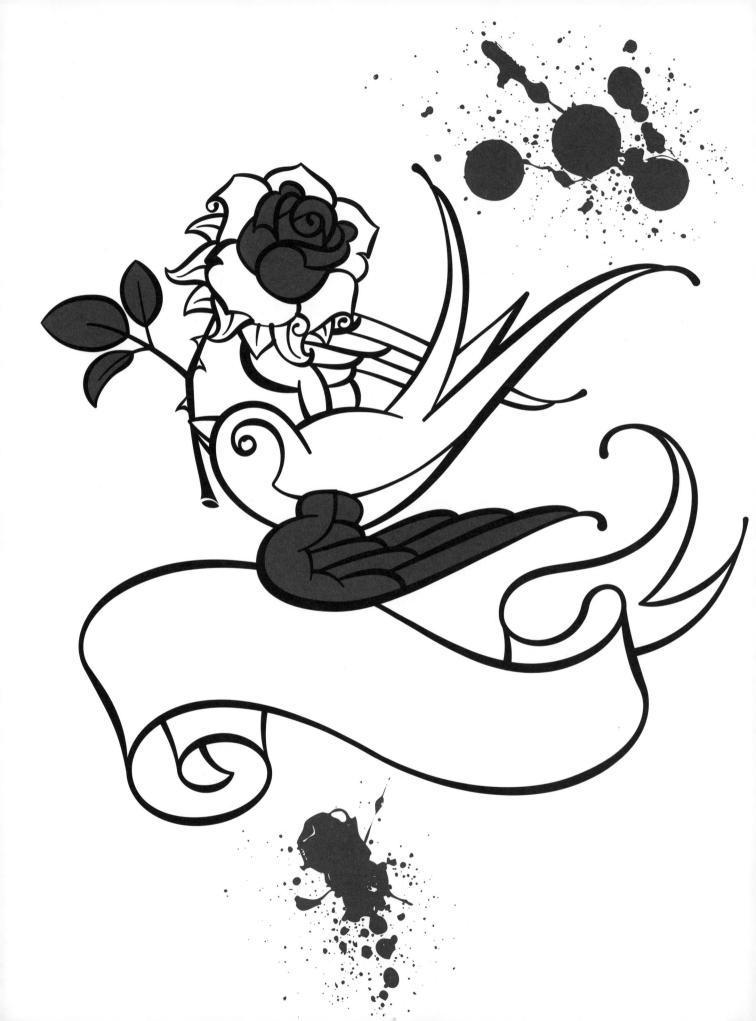

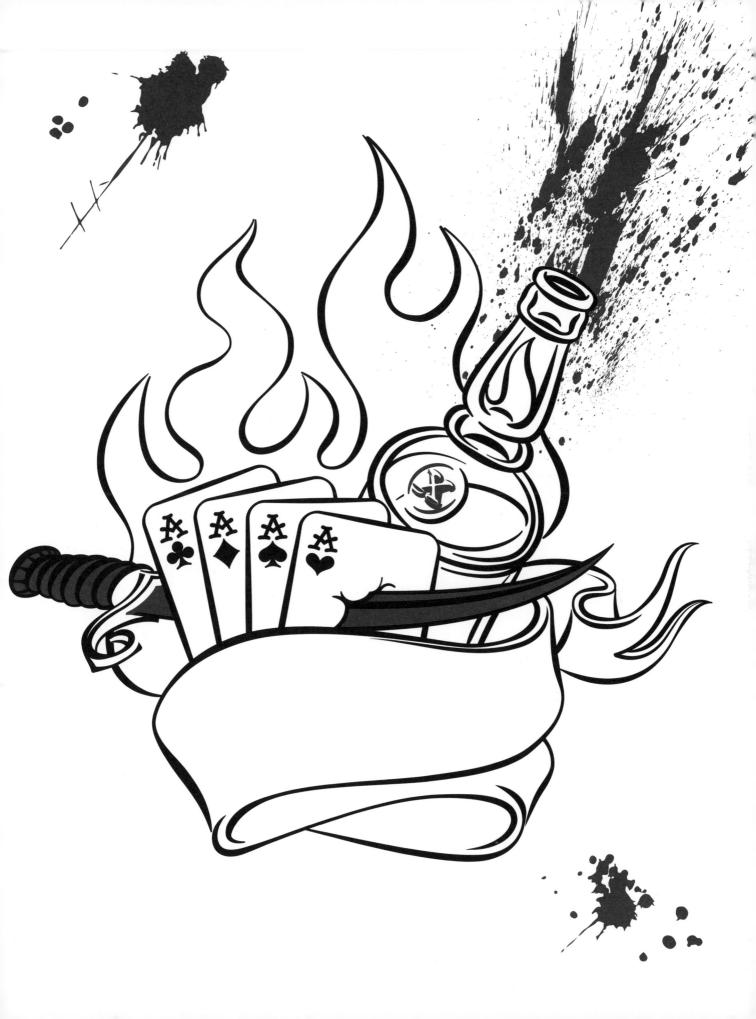

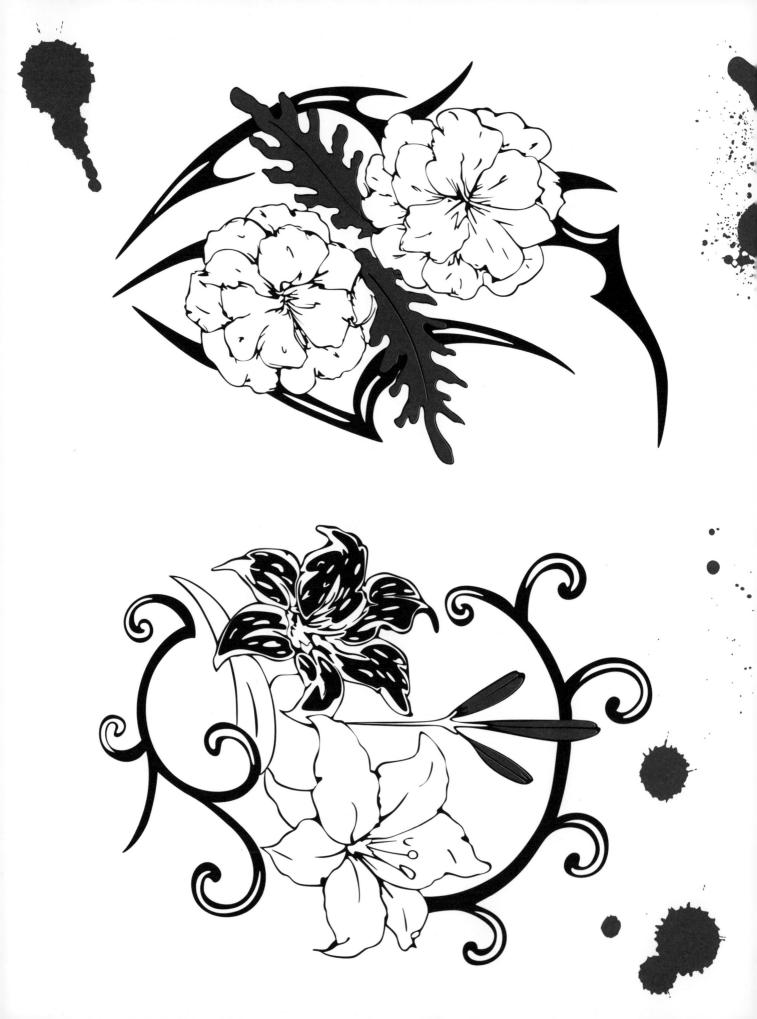

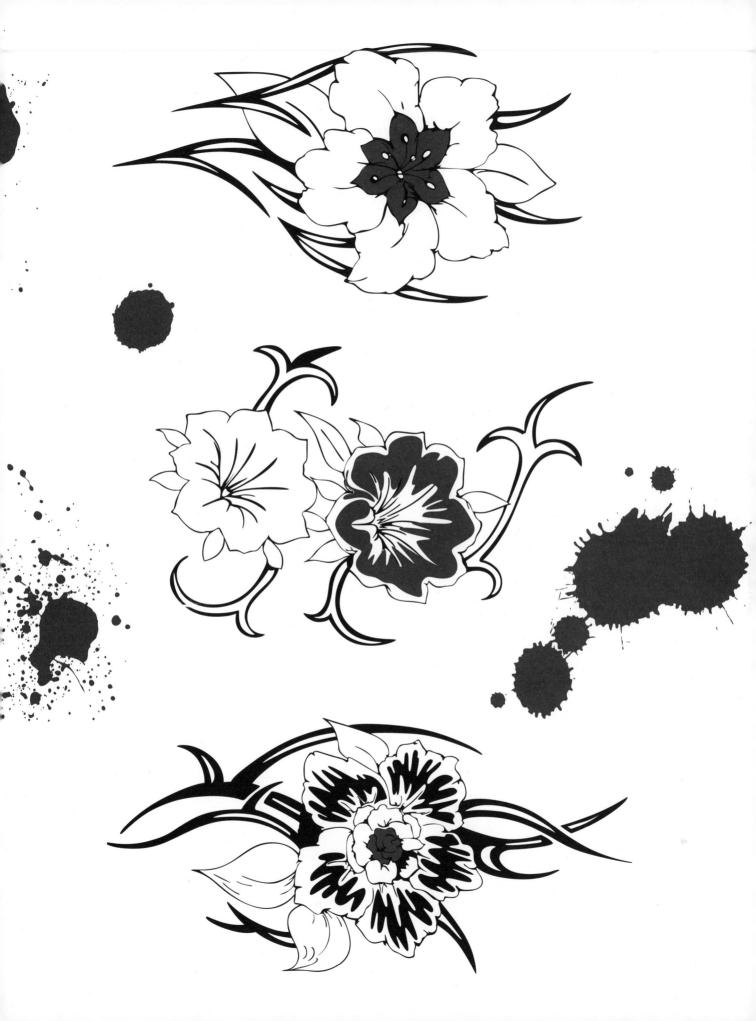

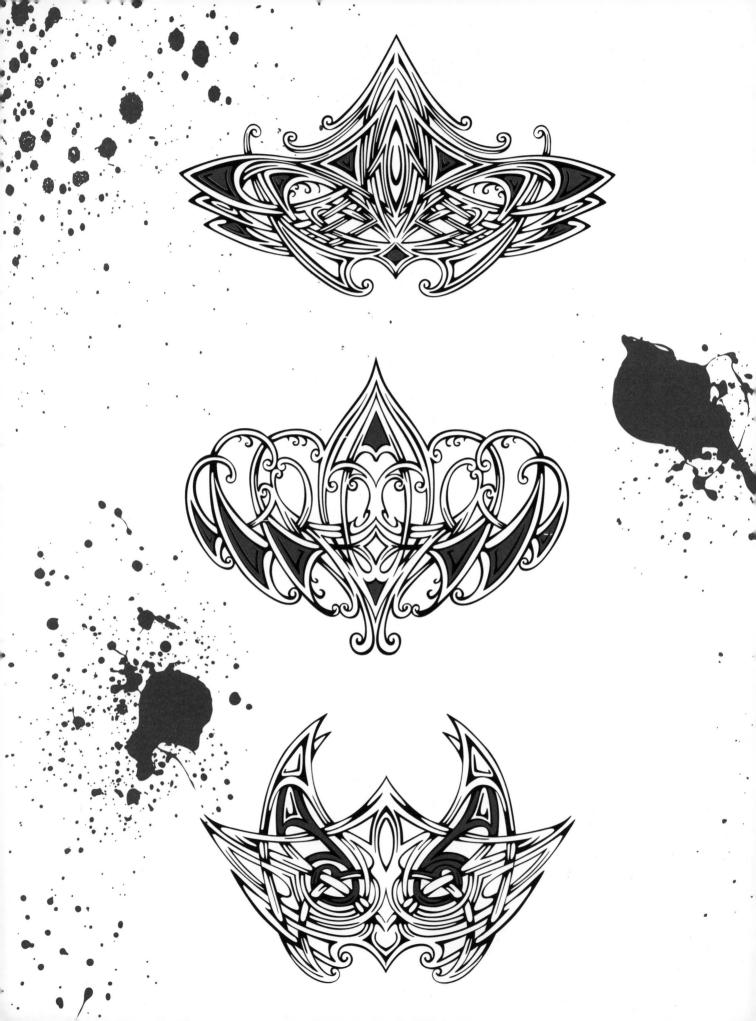

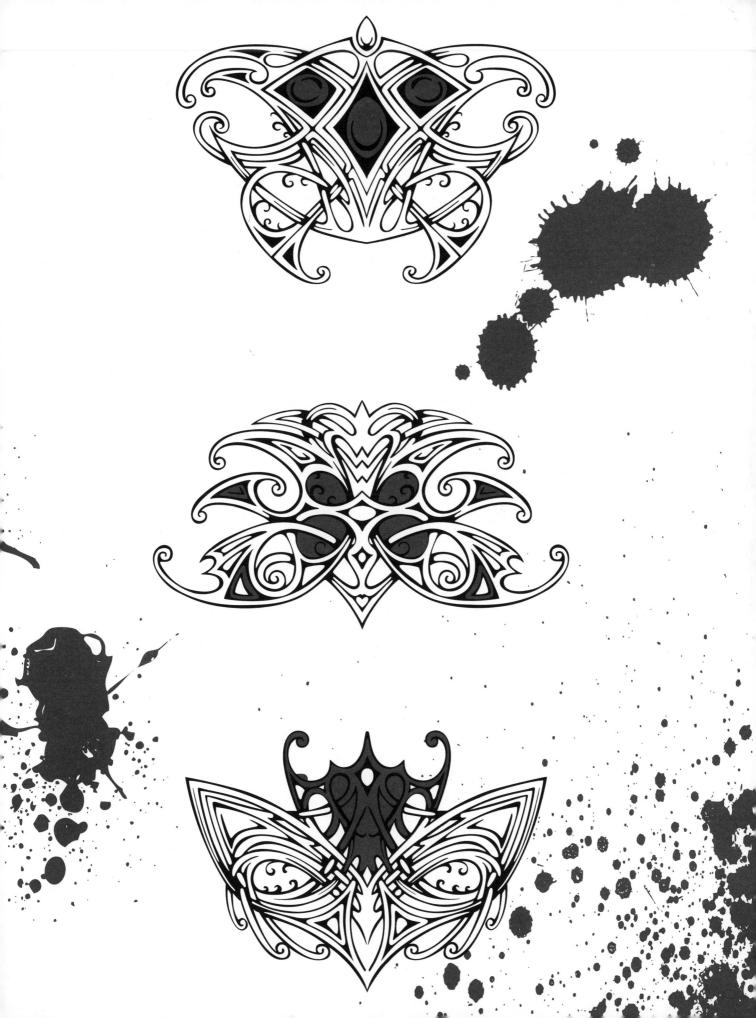

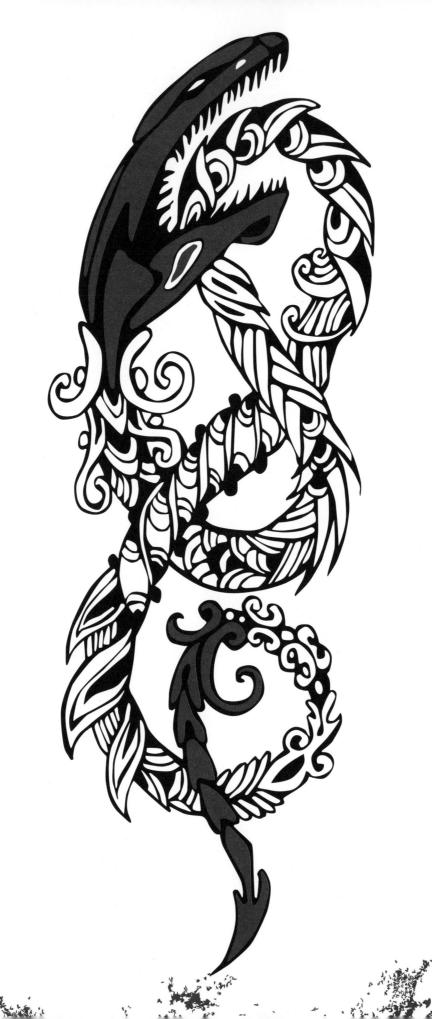

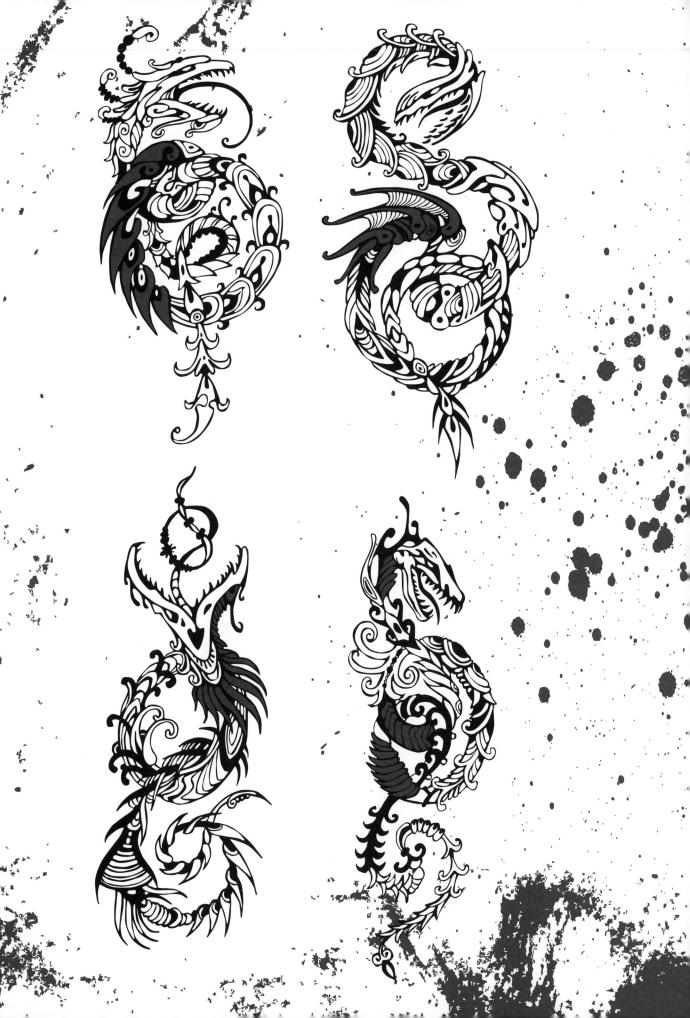

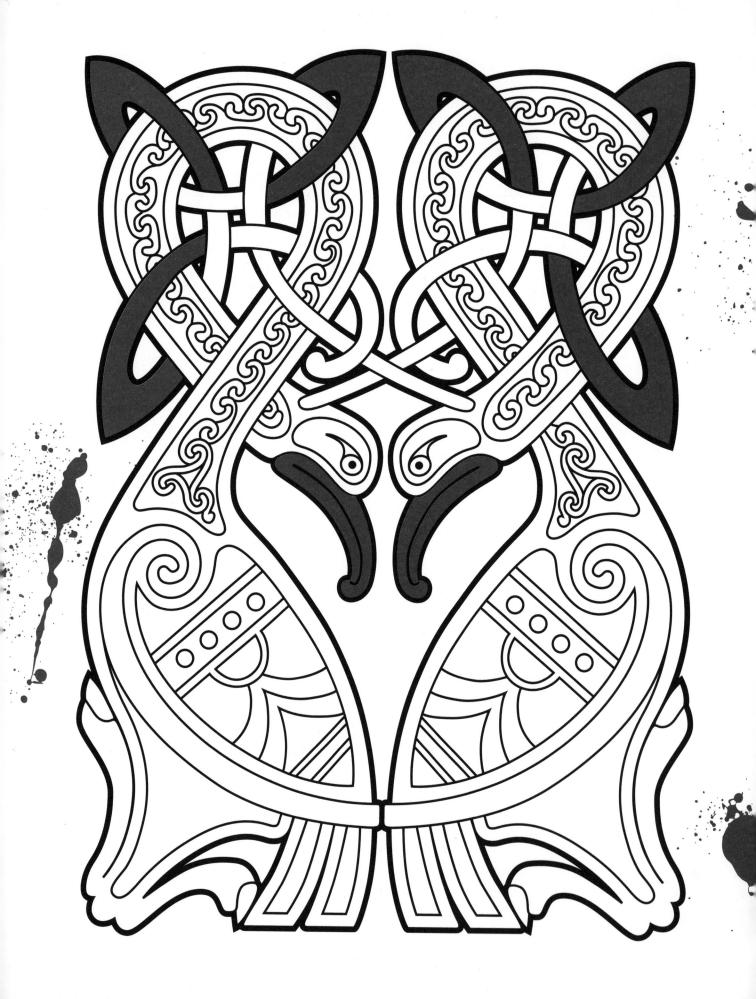

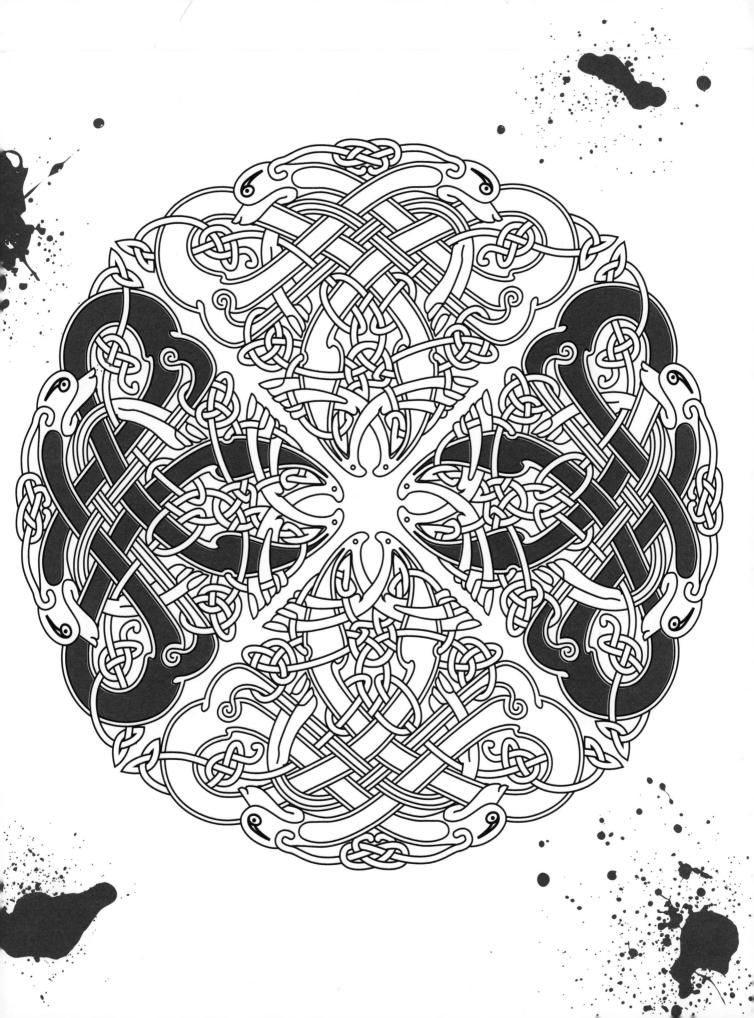

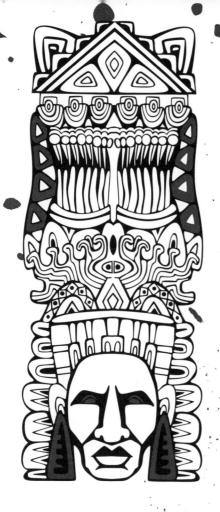

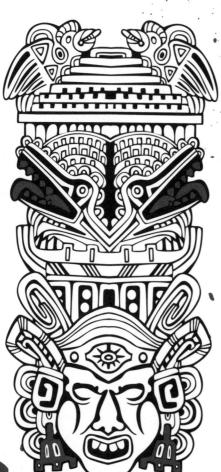

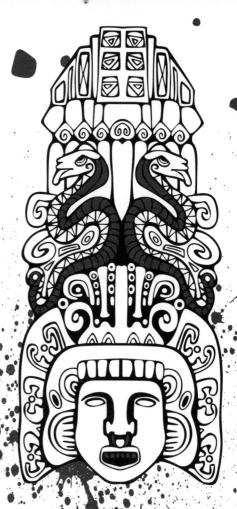

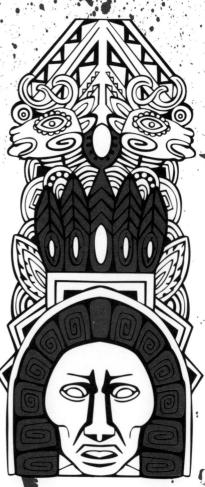

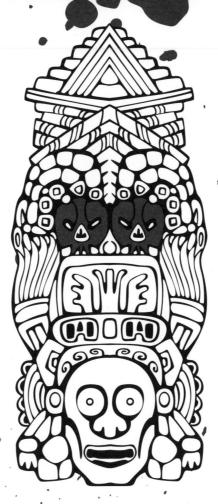

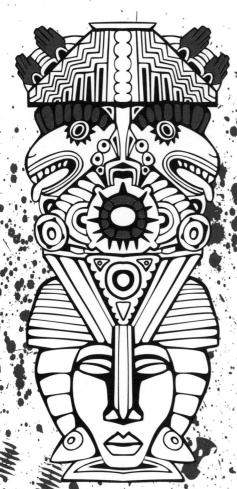

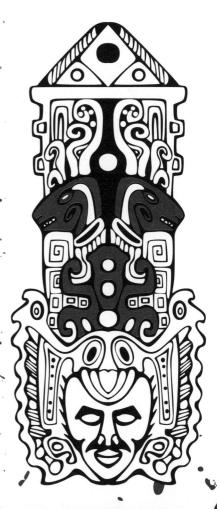

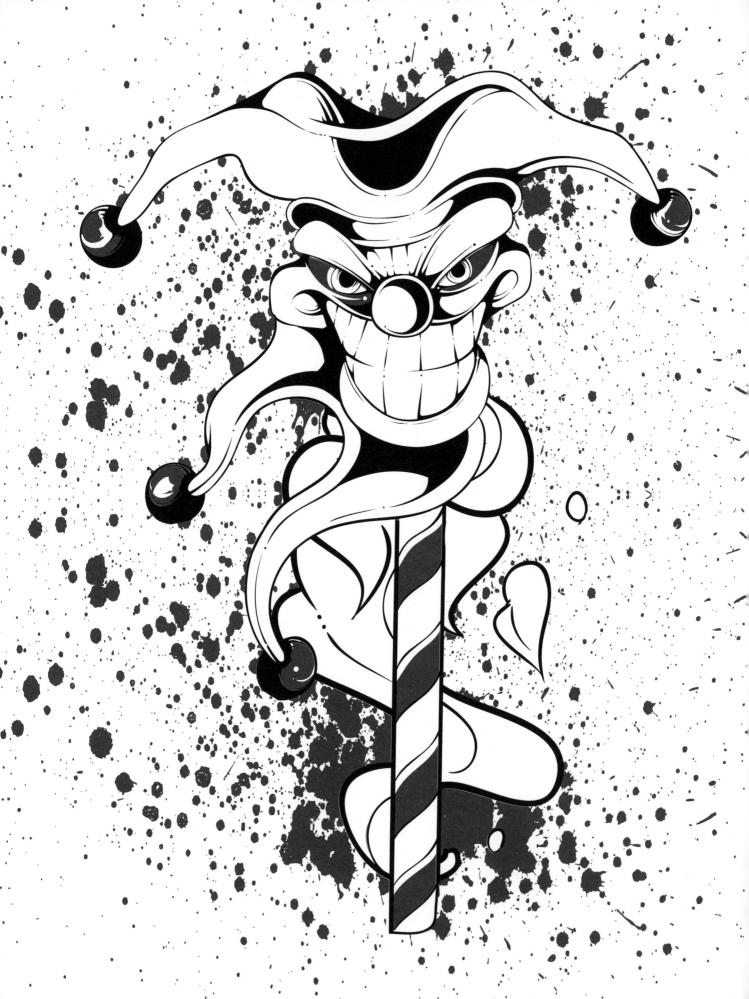

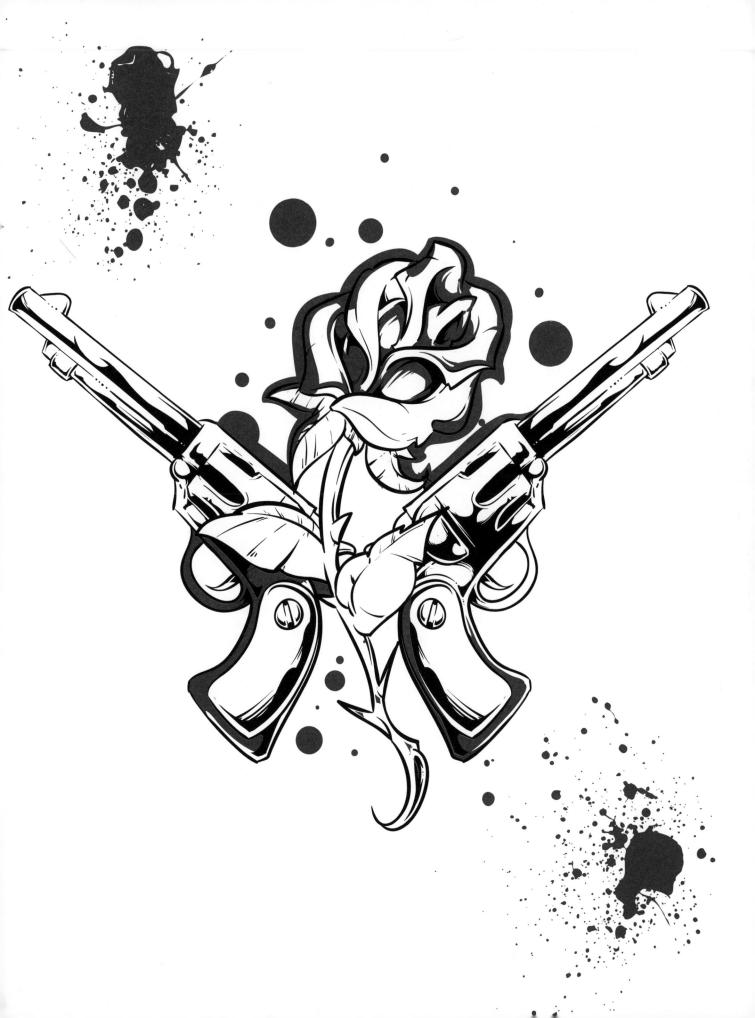

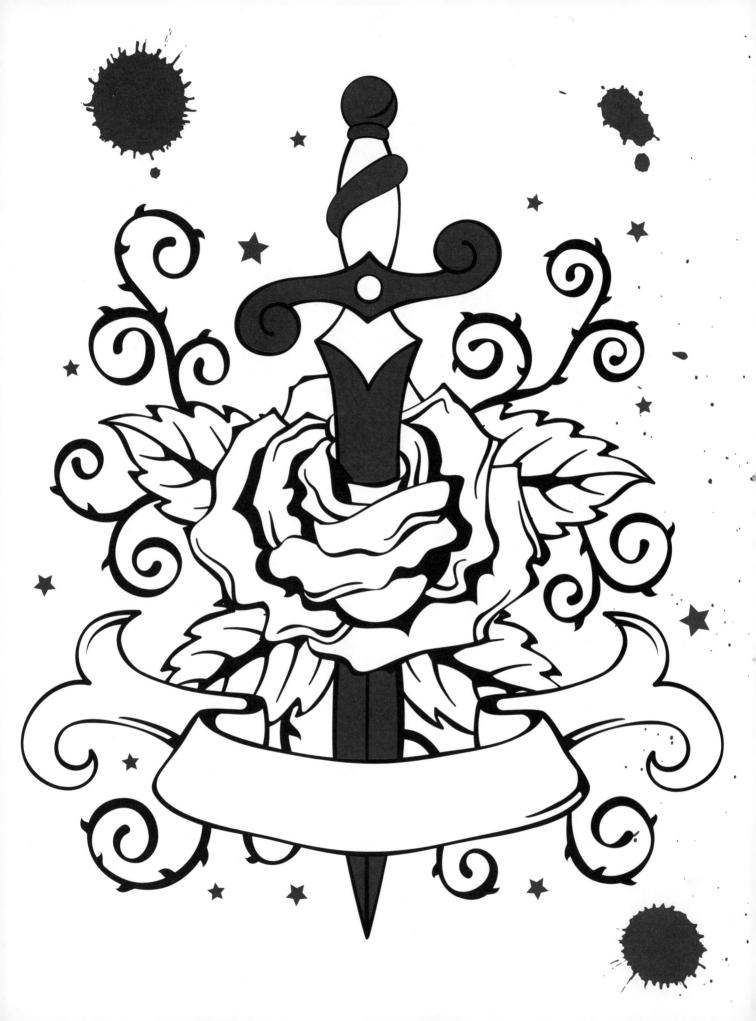

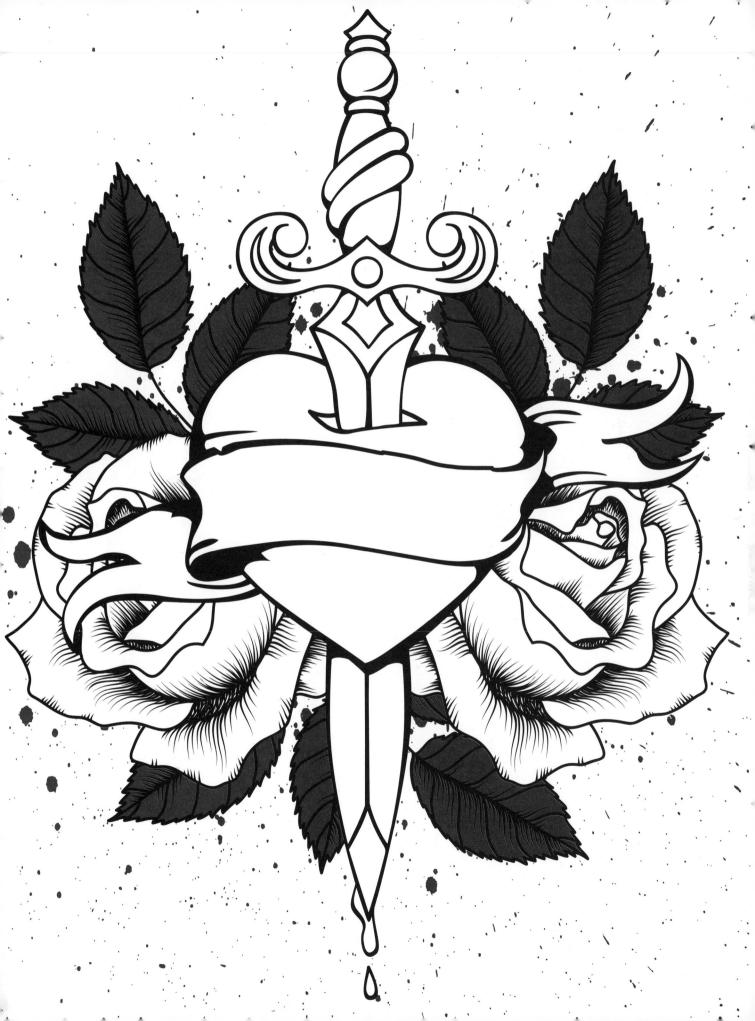

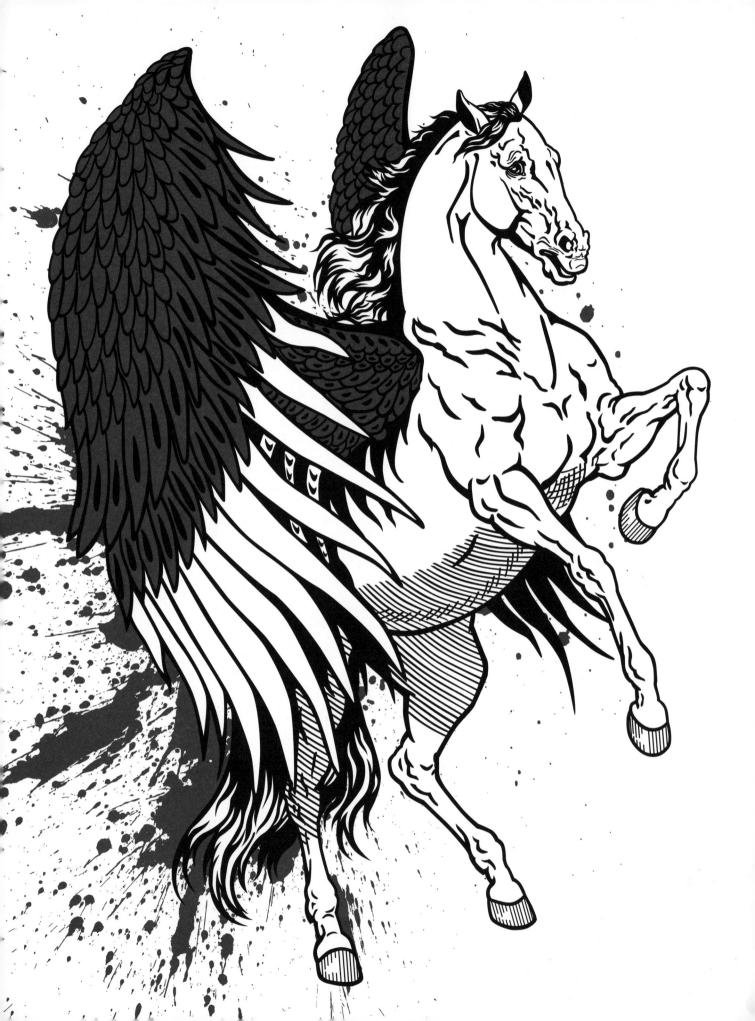

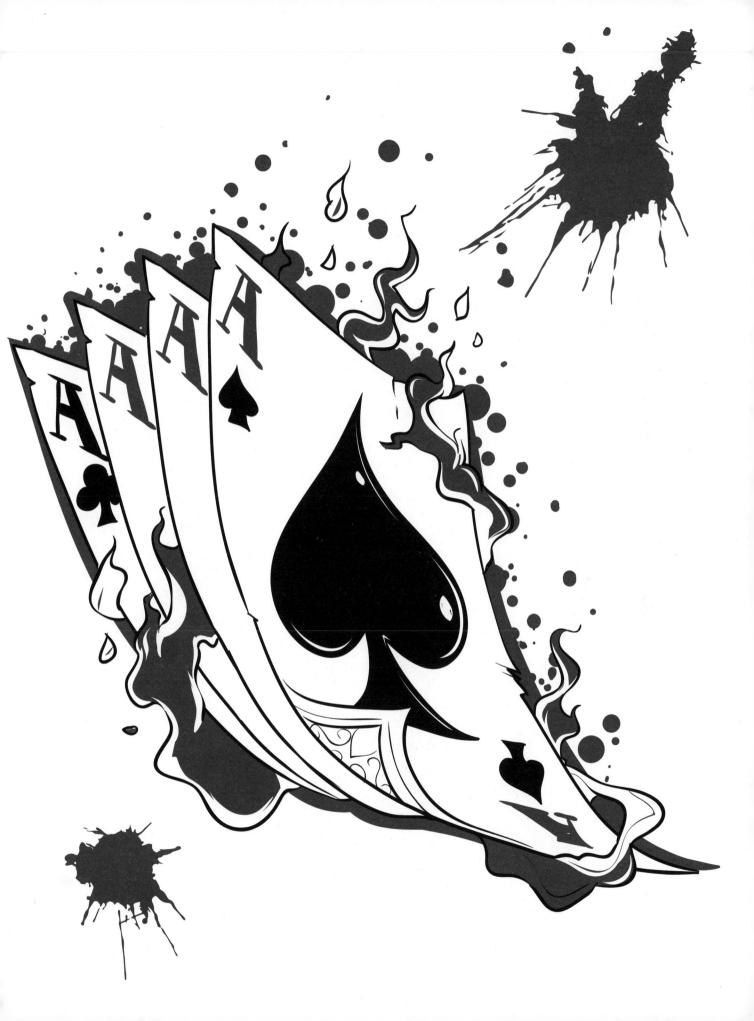

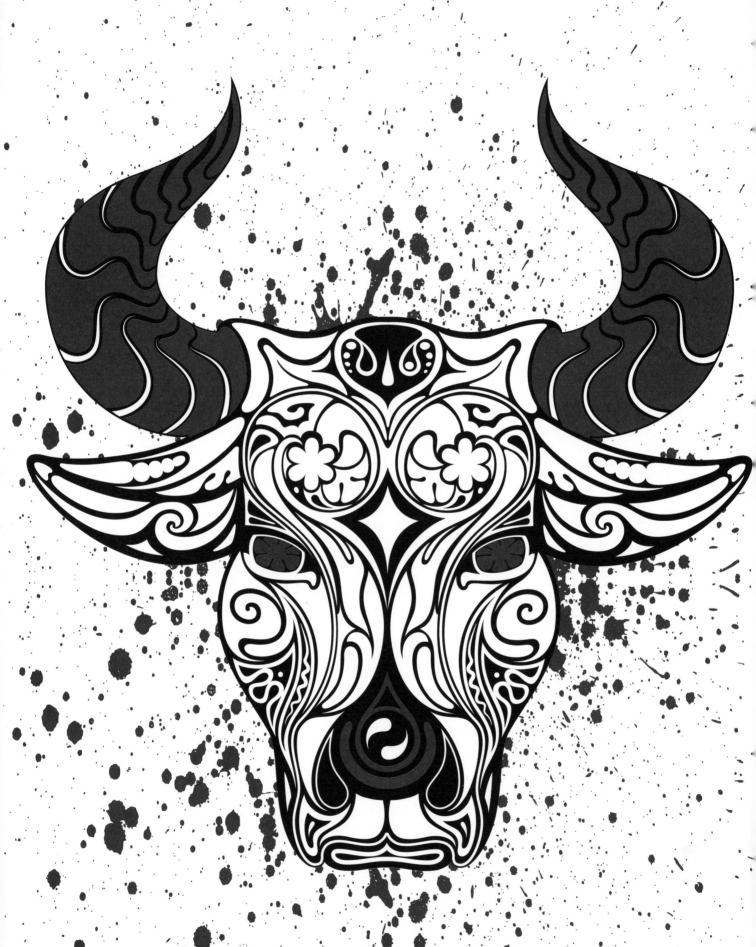

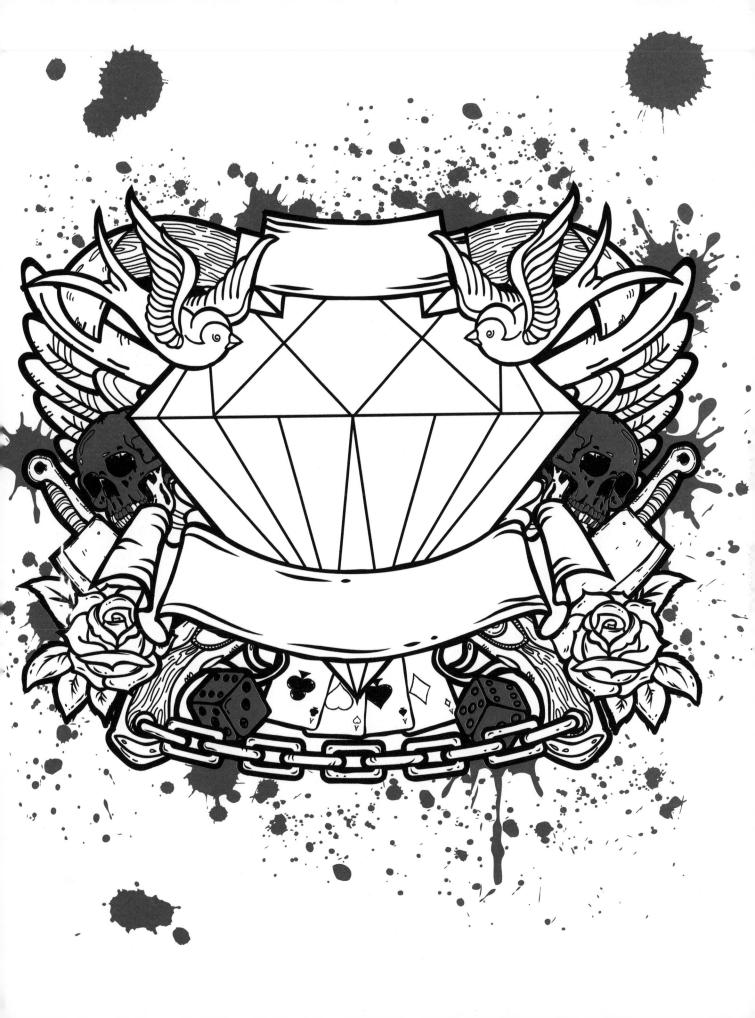

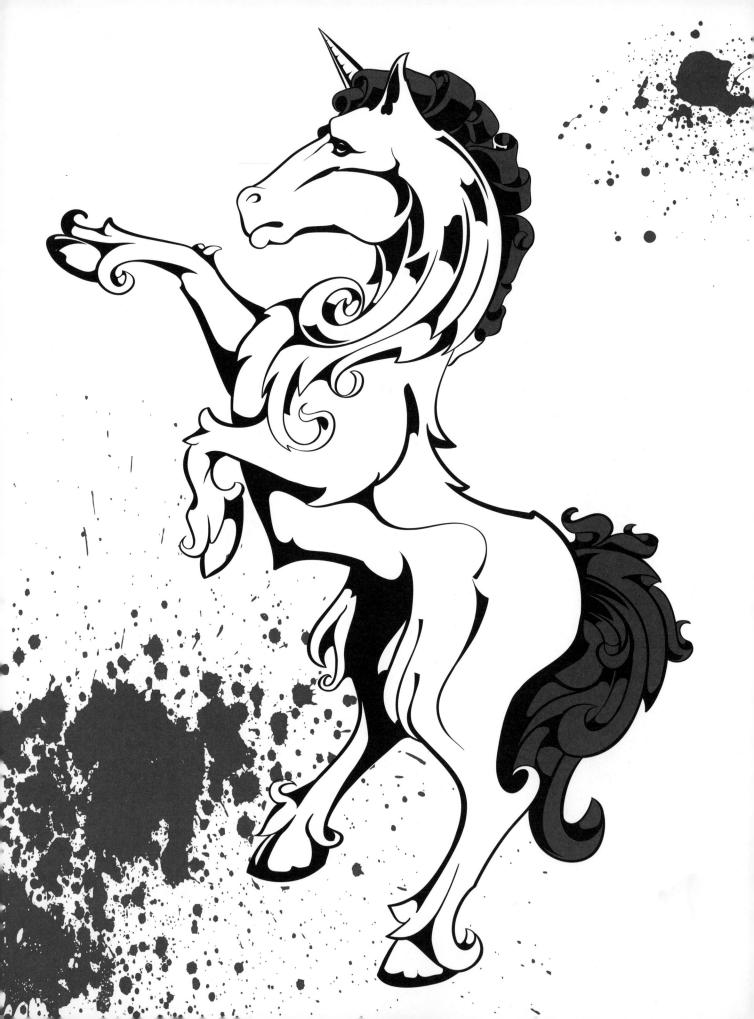

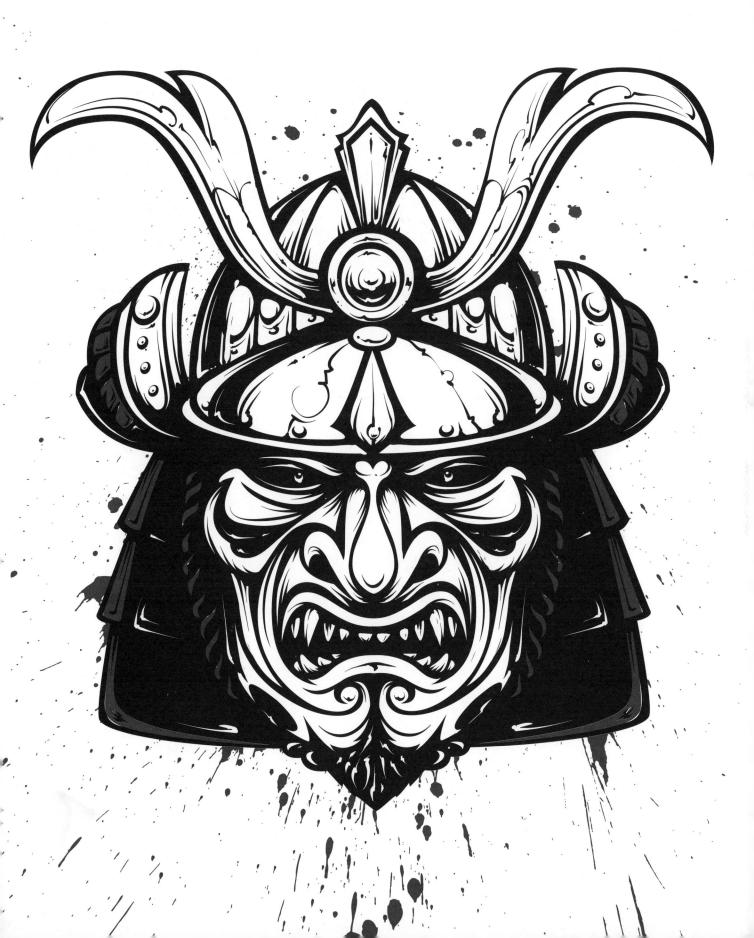

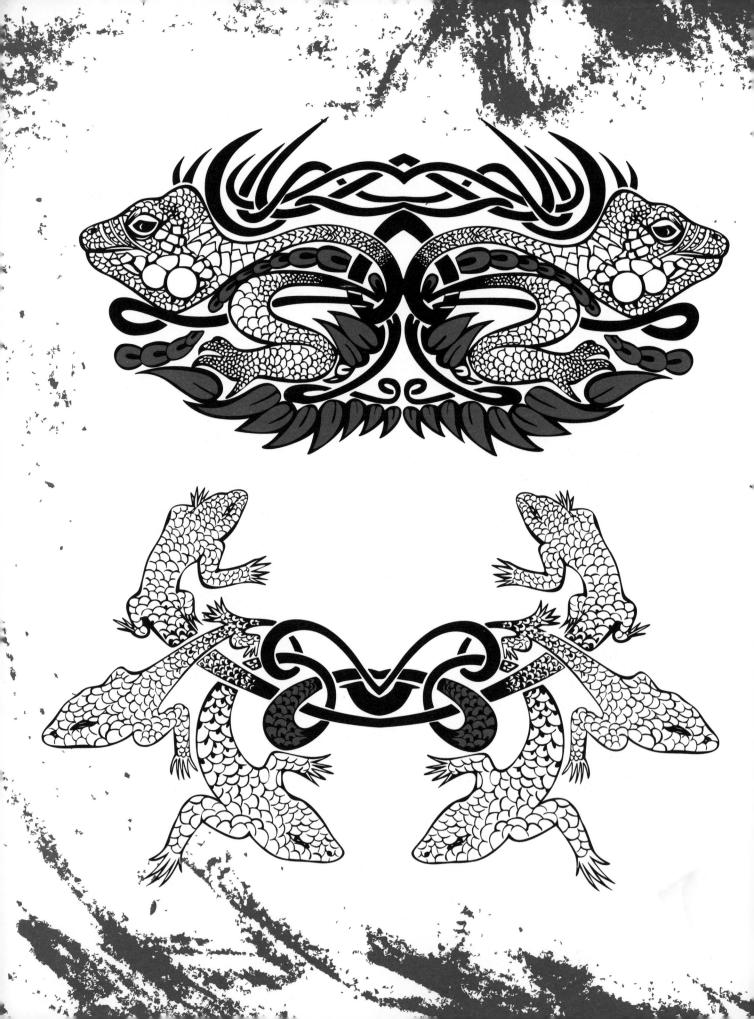

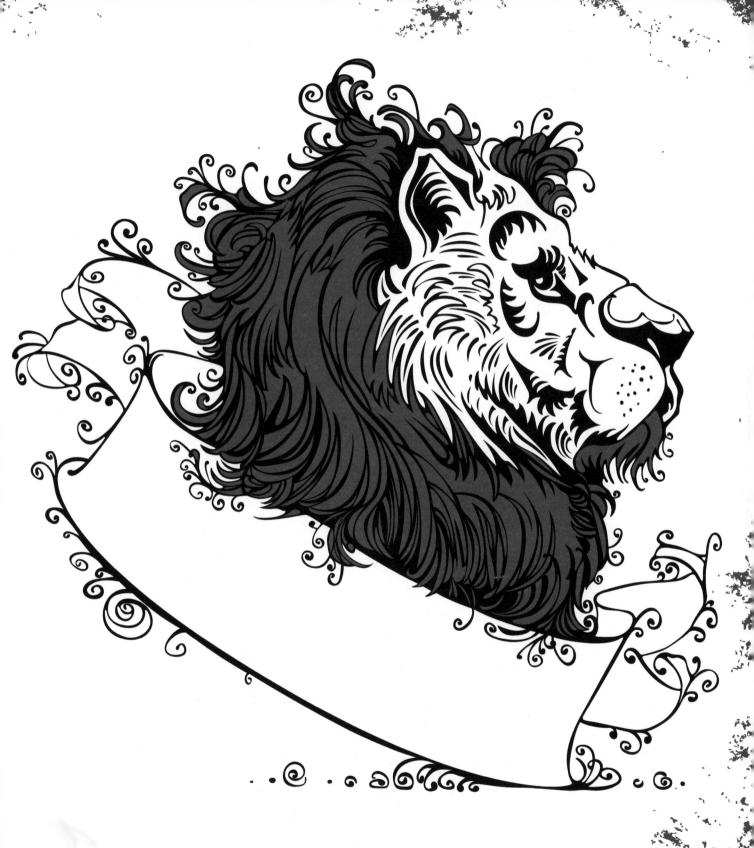

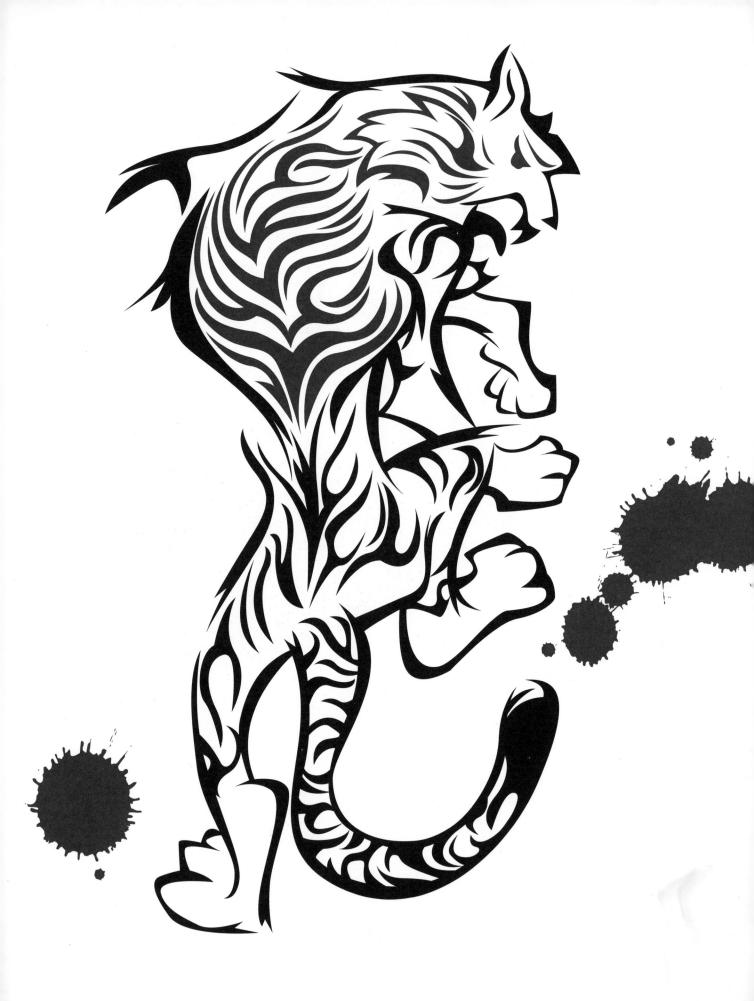

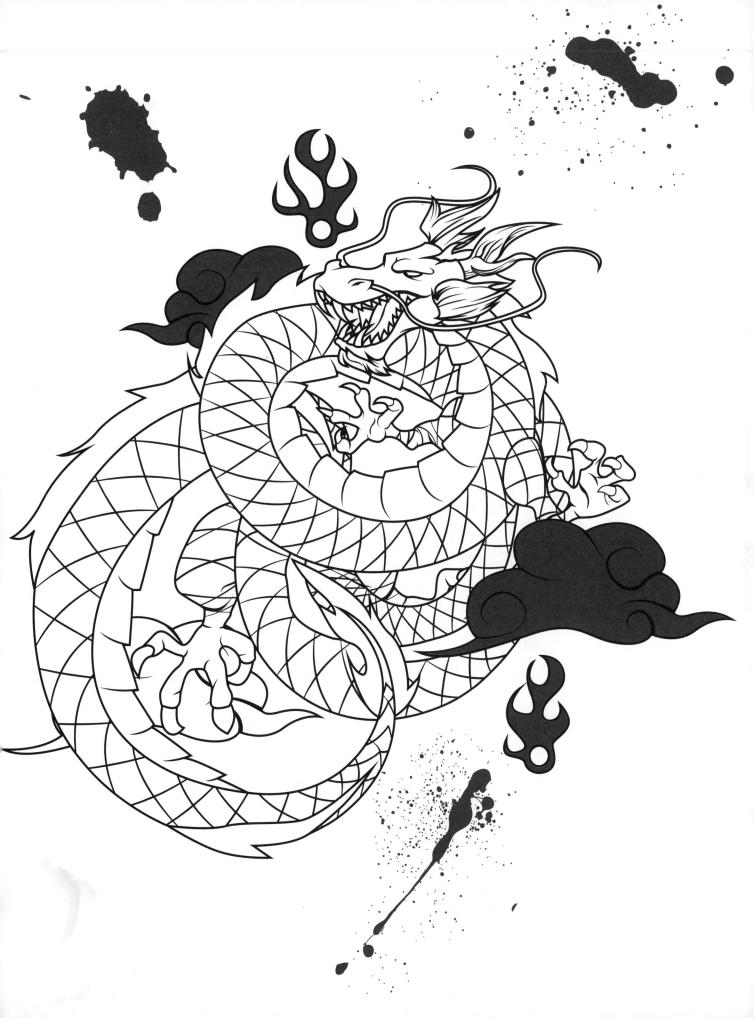

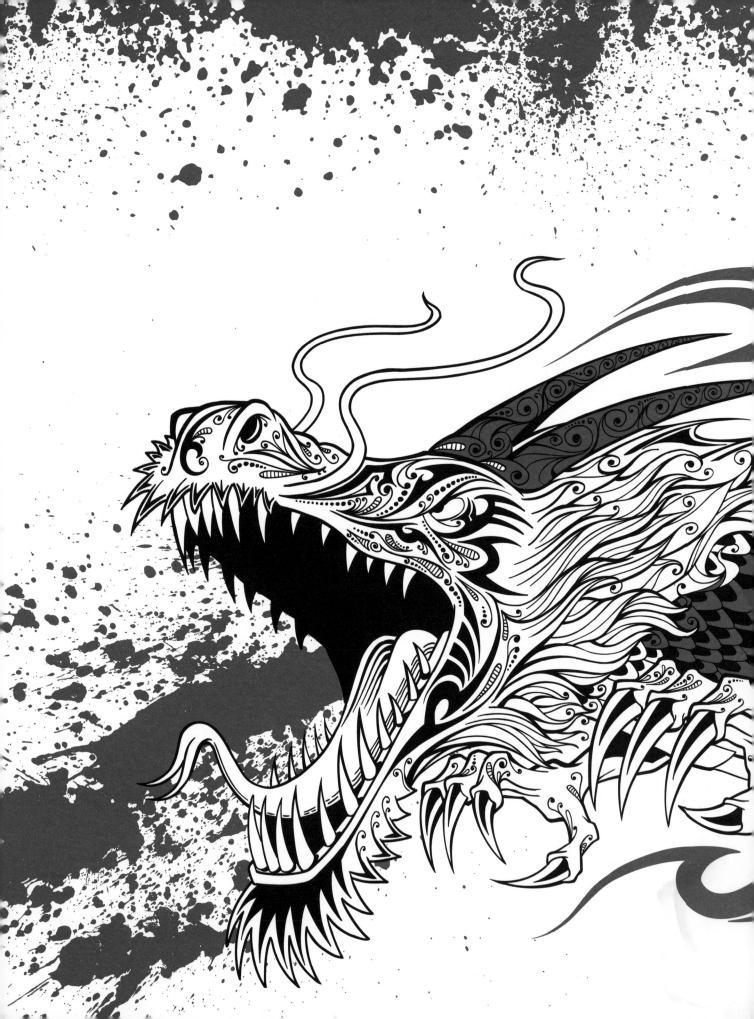

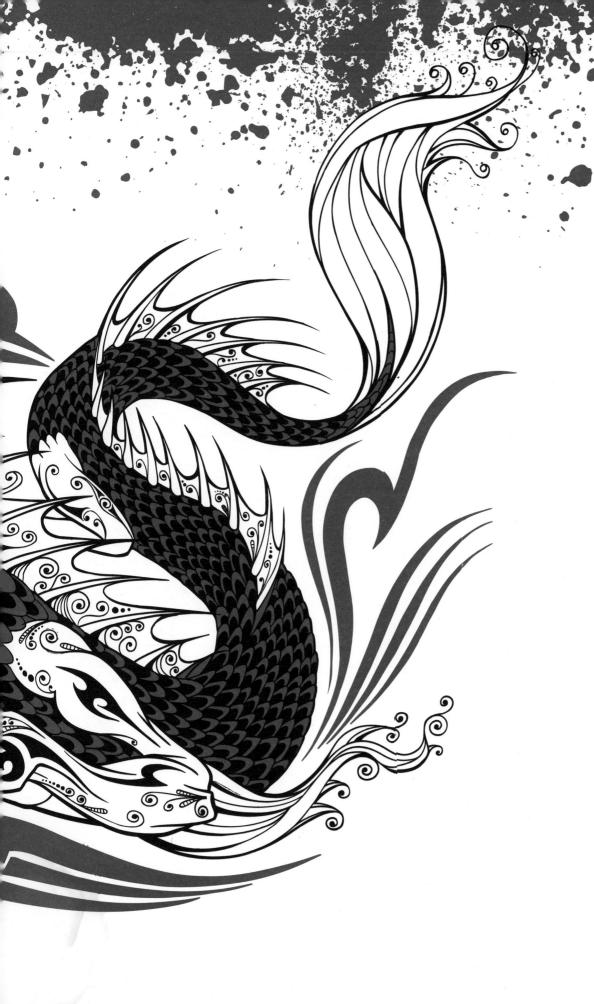

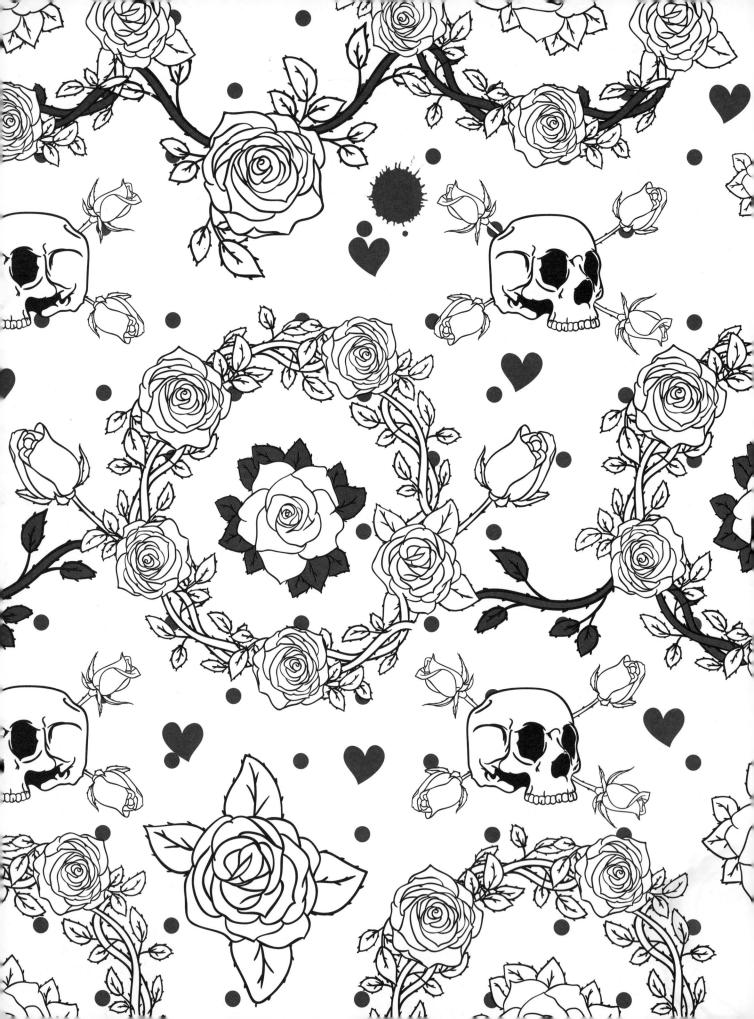

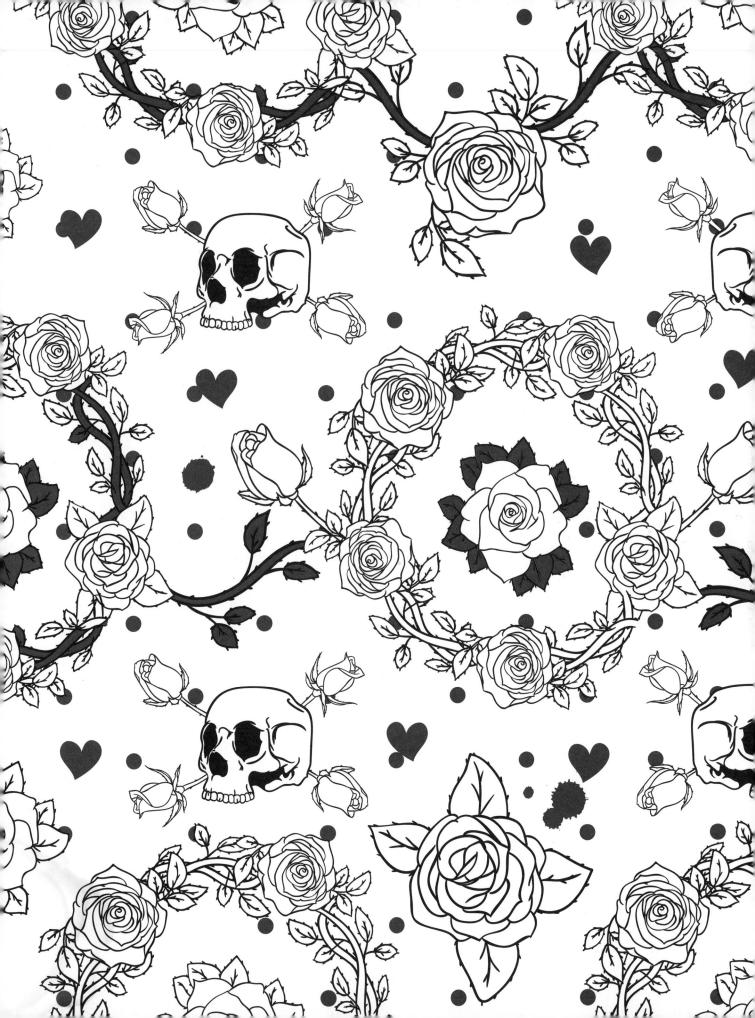